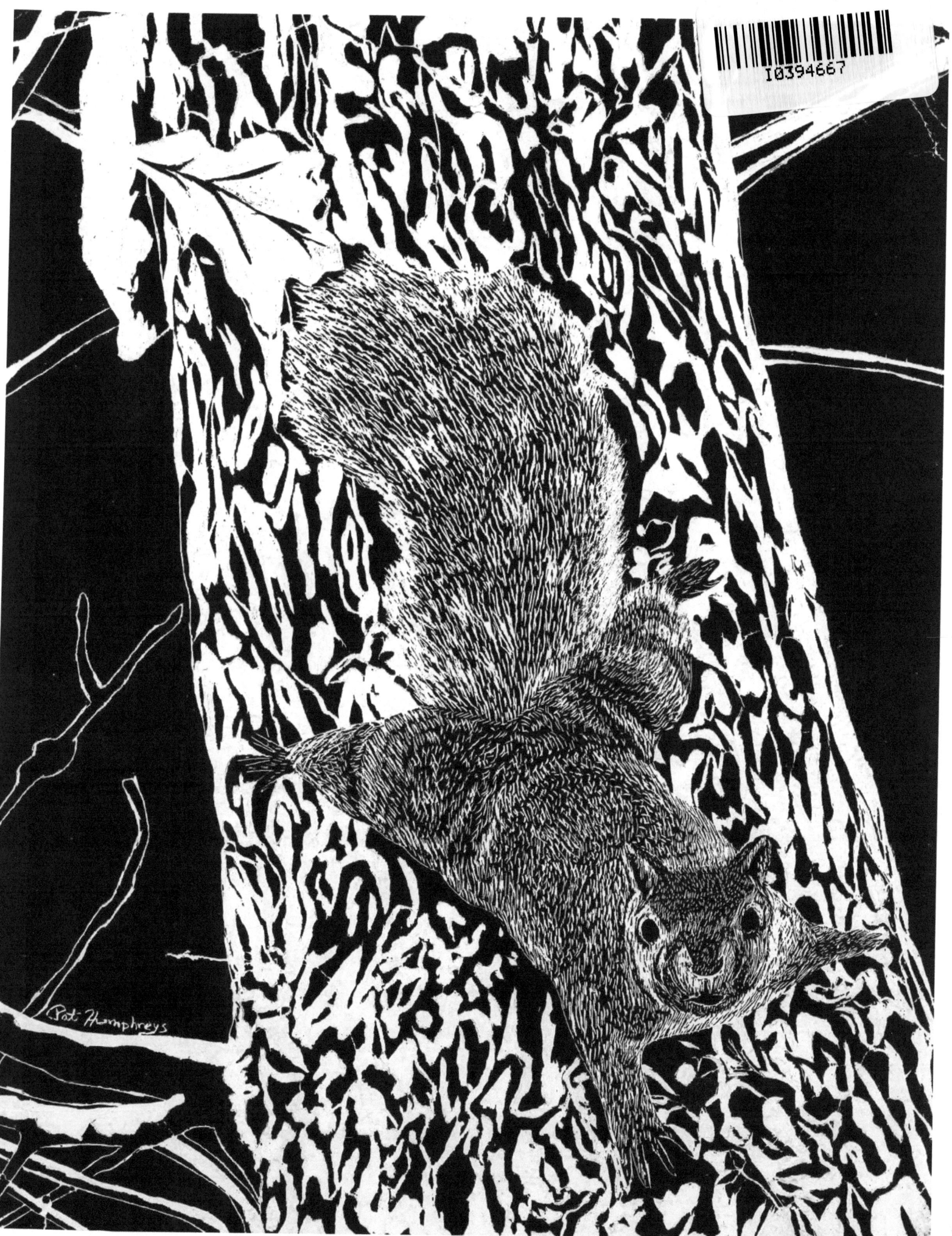

IT'S JUST A SCRATCH!

IT'S JUST A SCRATCH: INTRODUCTION

This book contains images created using scratchboard. Scratchboard is a very little used and very misunderstood medium. This book is not a book about the techniques to create your own scratchboards, but rather is a visual record of my experiences with scratchboard.

I first witnessed scratchboard in high school. The cover image of the squirrel on a tree is one of my first successful scratchboards. This image was done on scratchboard that is on paper. This type of scratchboard is the one most people experience in high school. For most people, this is the beginning and end of using this misunderstood art form. Figure 1: *I'm Horny*, scratchboard on paper, 1987 and Figure 2: *Baby!*, scratchboard on paper, 1987 are the only remaining early examples of mine. These images are of my own original cartoons. I wanted to be a cartoonist at this time. Since that time I have received an MFA in painting from Western Michigan University in Kalamazoo, Michigan.

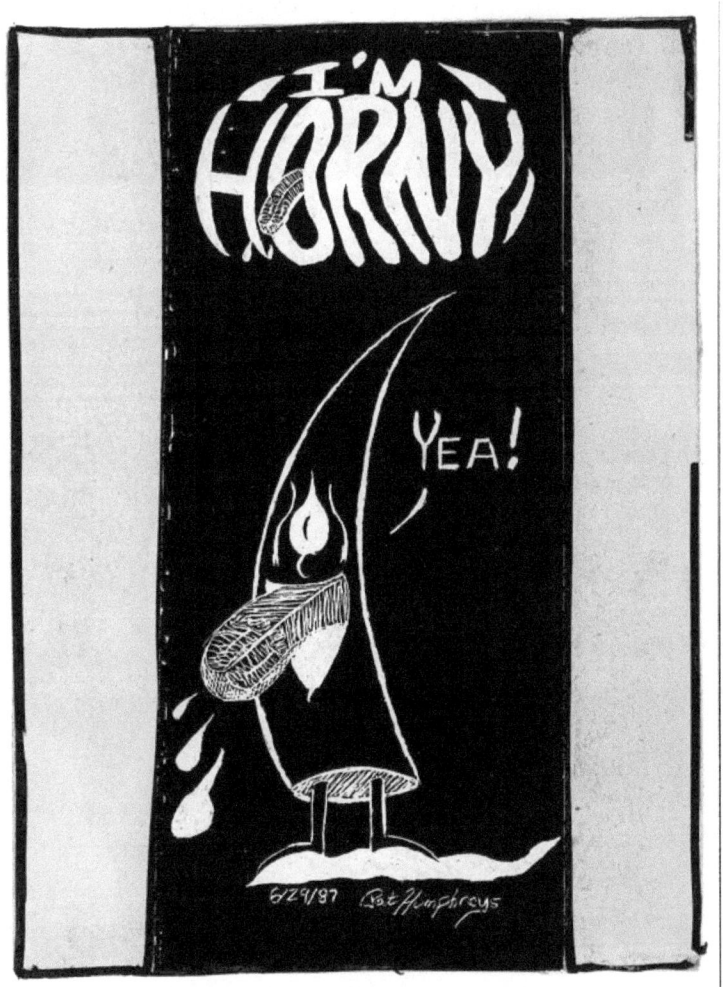

Figure 1: *I'm Horny*; Scratchboard on Paper, 1987, 5"x7"

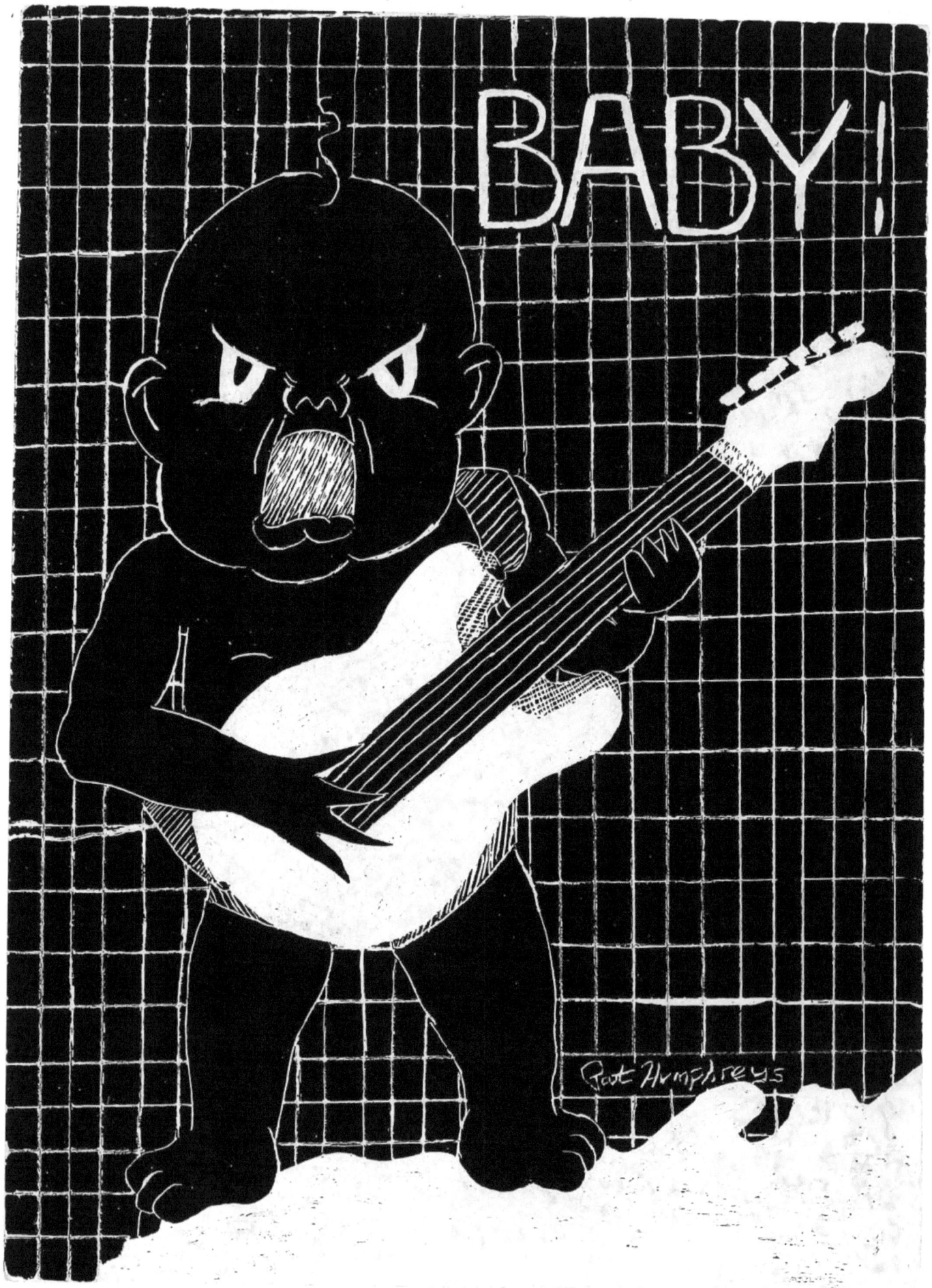

Figure 2: *Baby!* , Scratchboard on Paper, 1987, 5"x7"

CHAPTER 1: REINTRODUCTION TO SCRATCHBOARD

My experiences with scratchboard continued many, many years later. In the meantime, I received a MFA in painting from Western Michigan University. While there I met my future wife (divorced since then) and we had a son, Cameron, 10 years old at the time of writing this book.

My love of art took me to the local art supply store. While there I saw and purchased Ampersand Scratchbords, 5"x7", 3 pack. These scratchboards are unlike the paper ones we used in high school. They are created on a hard board covered with clay and coated with india ink to obtain a black surface where scratching away with a tool to uncover the white to create a drawing in reverse. Figure 3: _Work in Progress_ is an example of this. Visit www.ampersandart.com to see the details of these scratchboards. They call them scratchbords. Not a misspelling. I personally prefer these scratchboards over the paper variety.

Furthermore, my love of art and love of my son, Cameron, created a strong desire to introduce my son to the world of scratchboards. Figure 4: _Good Kitty Collaboration_, scratchboard, 2012, 7"x5" was created by me and my son, Cameron. This image is based upon a painting I created in graduate school at WMU. It is a homage to the Willem DeKooning woman series of painting and my love of cats.

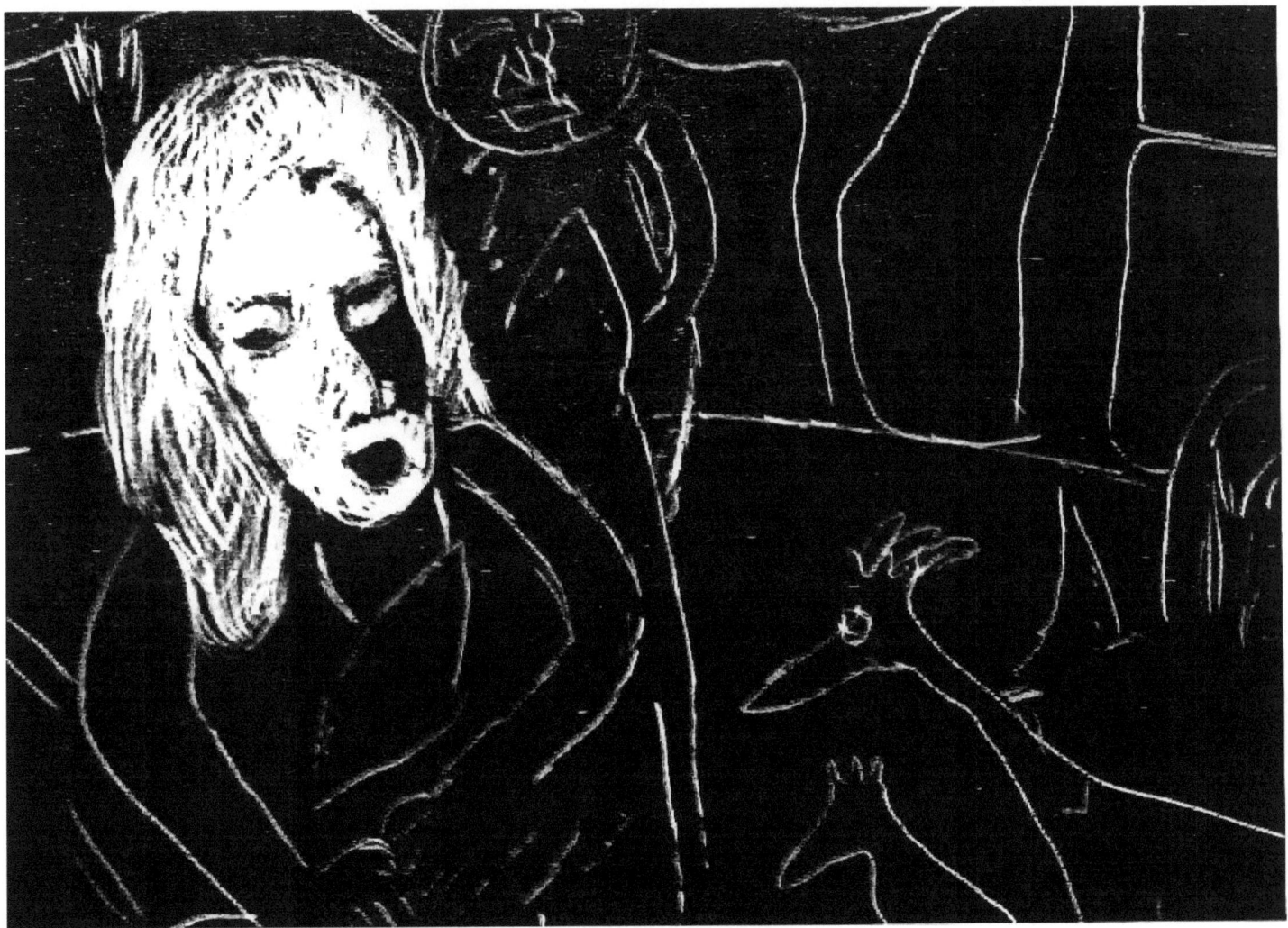

Figure 3: _Work in Progress_, Scratchboard on Paper, 2012, 14"x11"

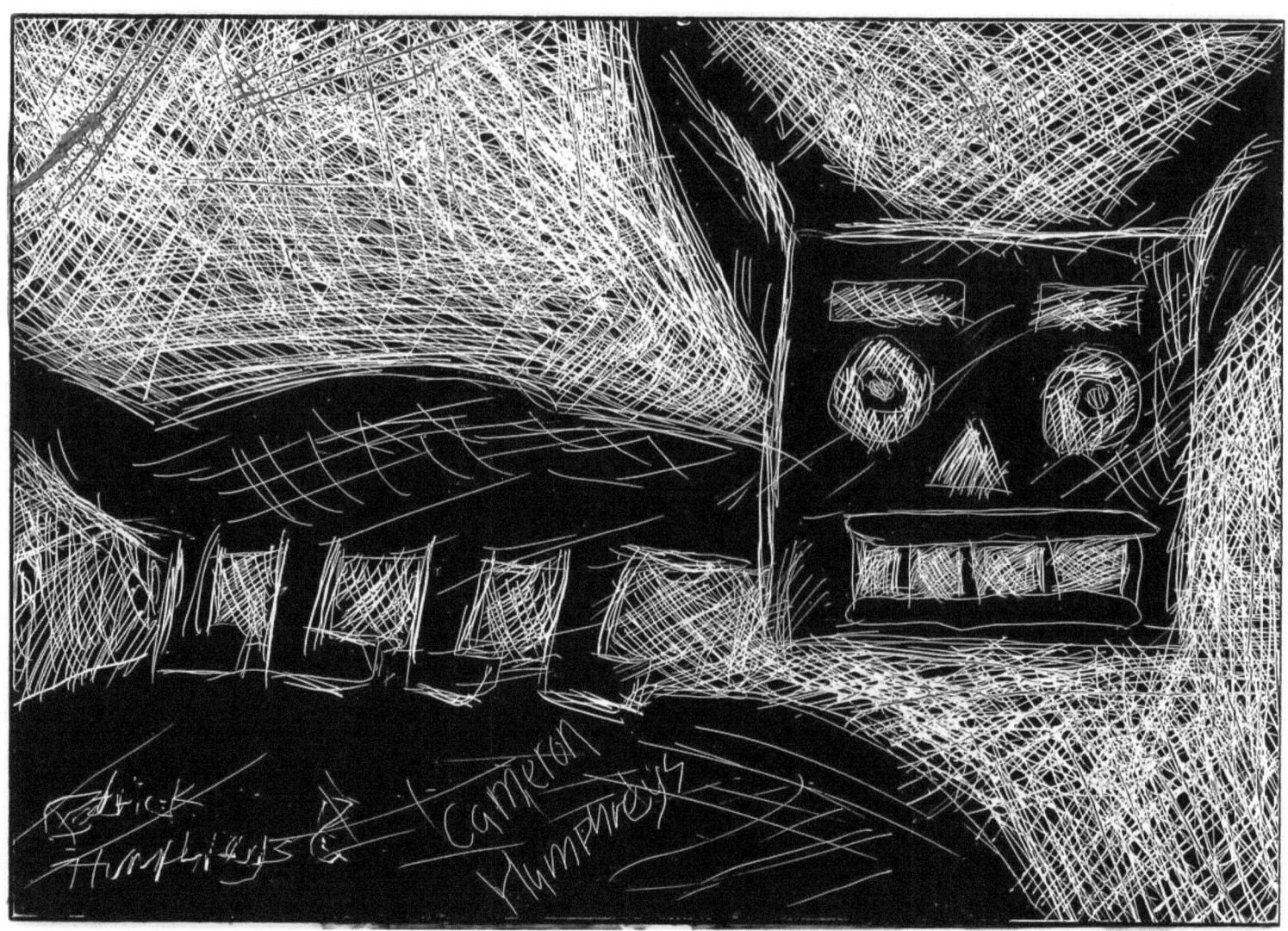

Figure 4: *Good Kitty Collaboration*, Scratchboard, 2012, 7"x5", Patrick and Cameron Humphreys

CHAPTER 2: CAMERON'S SCRATCHBOARDS

This chapter illustrates my son's work with scratchboards. As with any child, he has a fondness for cartoons (I also have a fondness of cartoons!) Figure 5: <u>Bacon Man</u> is a good example of this. Why a bacon man? He says bacon is his favorite food. He could eat bacon all the time. This scratchboard is his personal homage to his love of this culinary food.

Another favorite food of Cameron is chicken nuggets. Hence, Figure 6: <u>Chicken Nugget Man</u>. These images are simple in nature but work well. The simple composition and cartoon style make these successful and make the viewer hungry for these beloved kids foods. Anybody with children knows that bacon and chicken nuggets are favorite foods for most children.

The next scratchboard, Figure 7, I helped Cameron a little bit. We currently live in Bay City, MI. We like to go to the local library. There is one branch in the Bay County Library System called Sage Library. This building is over 100 years old. A building with history and character. The only help I gave Cameron in the execution of this scratchboard is drawing the outline of this building. The interior line work and background were created just by Cameron. Figure 7 illustrates this. A very fine example of scratchboard art.

The last two scratchboards created by Cameron are also executed in the cartoon style. Figure 8: <u>Tic Tac Lizard</u> and Figure 9: <u>Mr. Triangle Man</u>. These two scratchboards are his latest images. He is "hungry" to create more scratchboards!

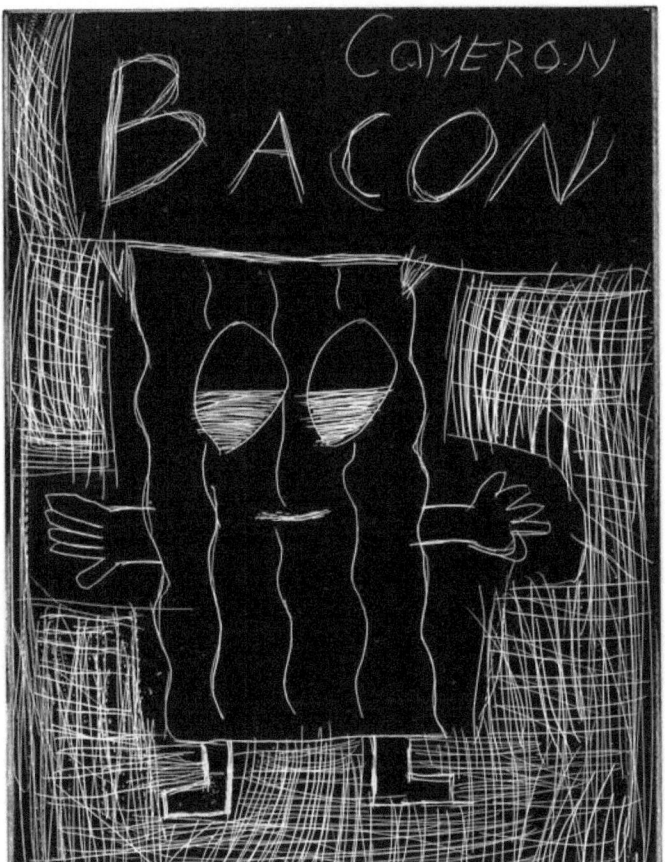

Figure 5: <u>Bacon Man</u>, Scratchboard, 2012, 5"x7", Cameron Humphreys

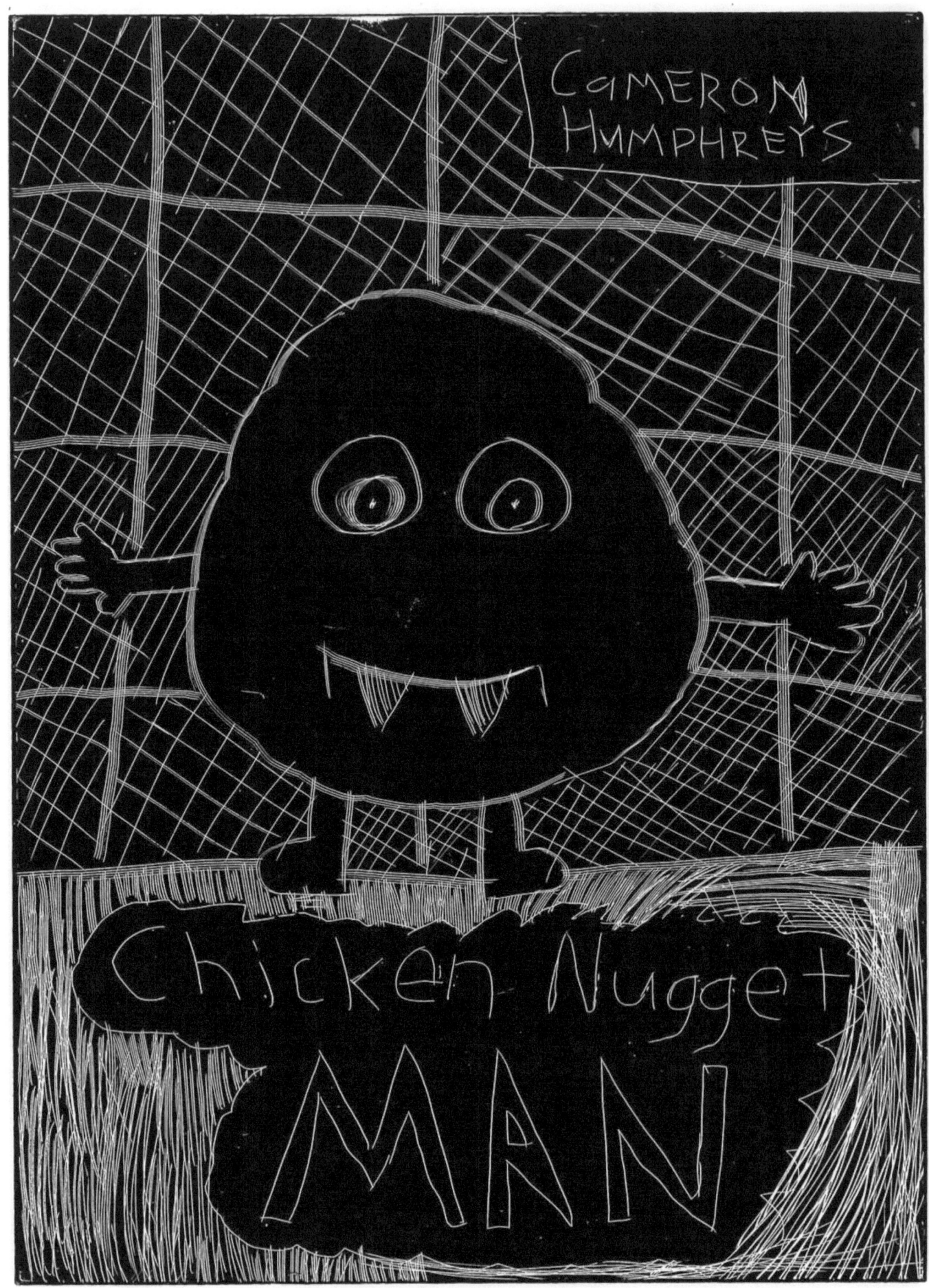

Figure 6: *Chicken Nugget Man*, Scratchboard, 2012, 5"x7", Cameron Humphreys

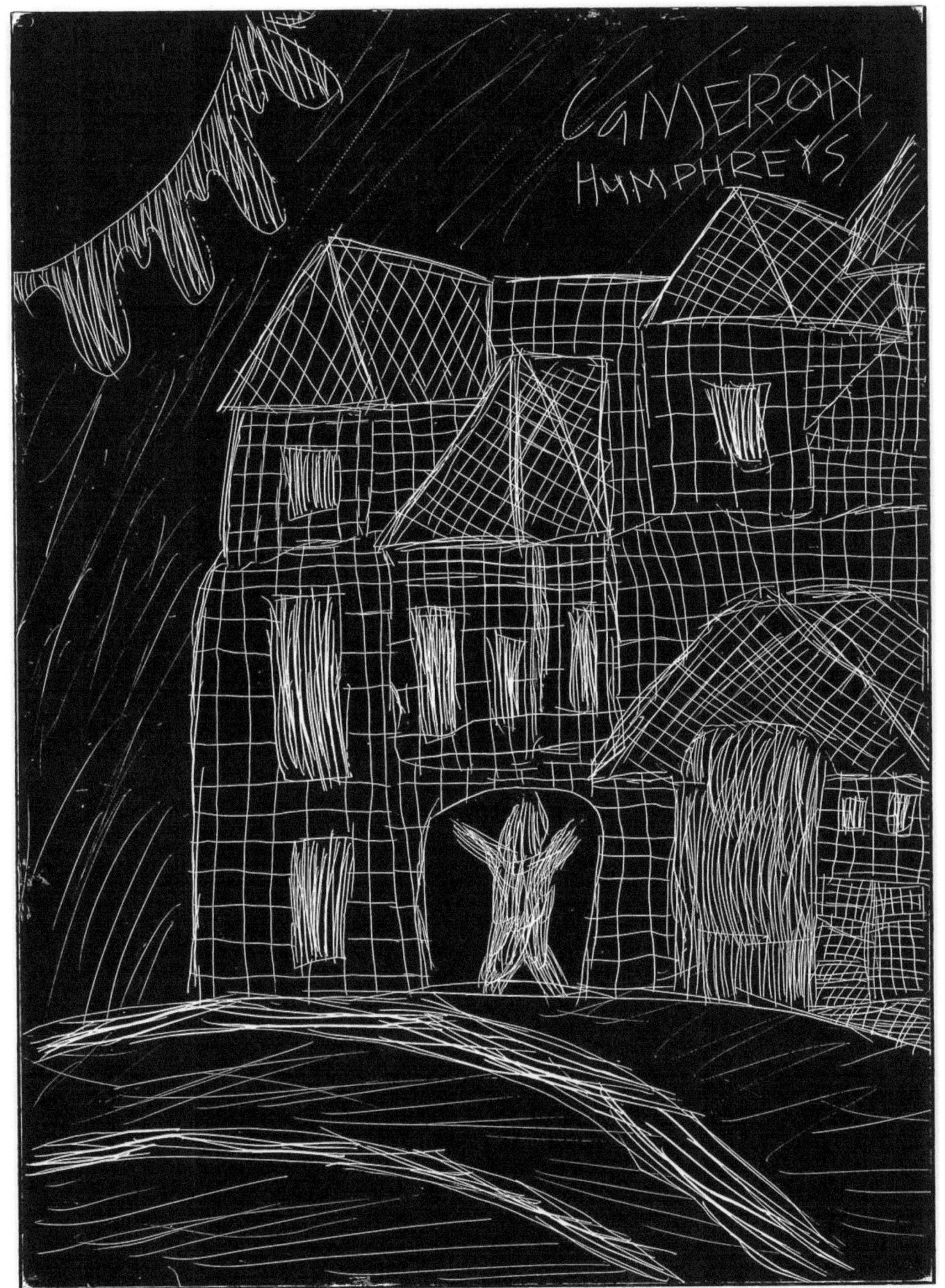

Figure 7: *Sage Library*, Scratchboard, 2012, 5"x7", Cameron Humphreys

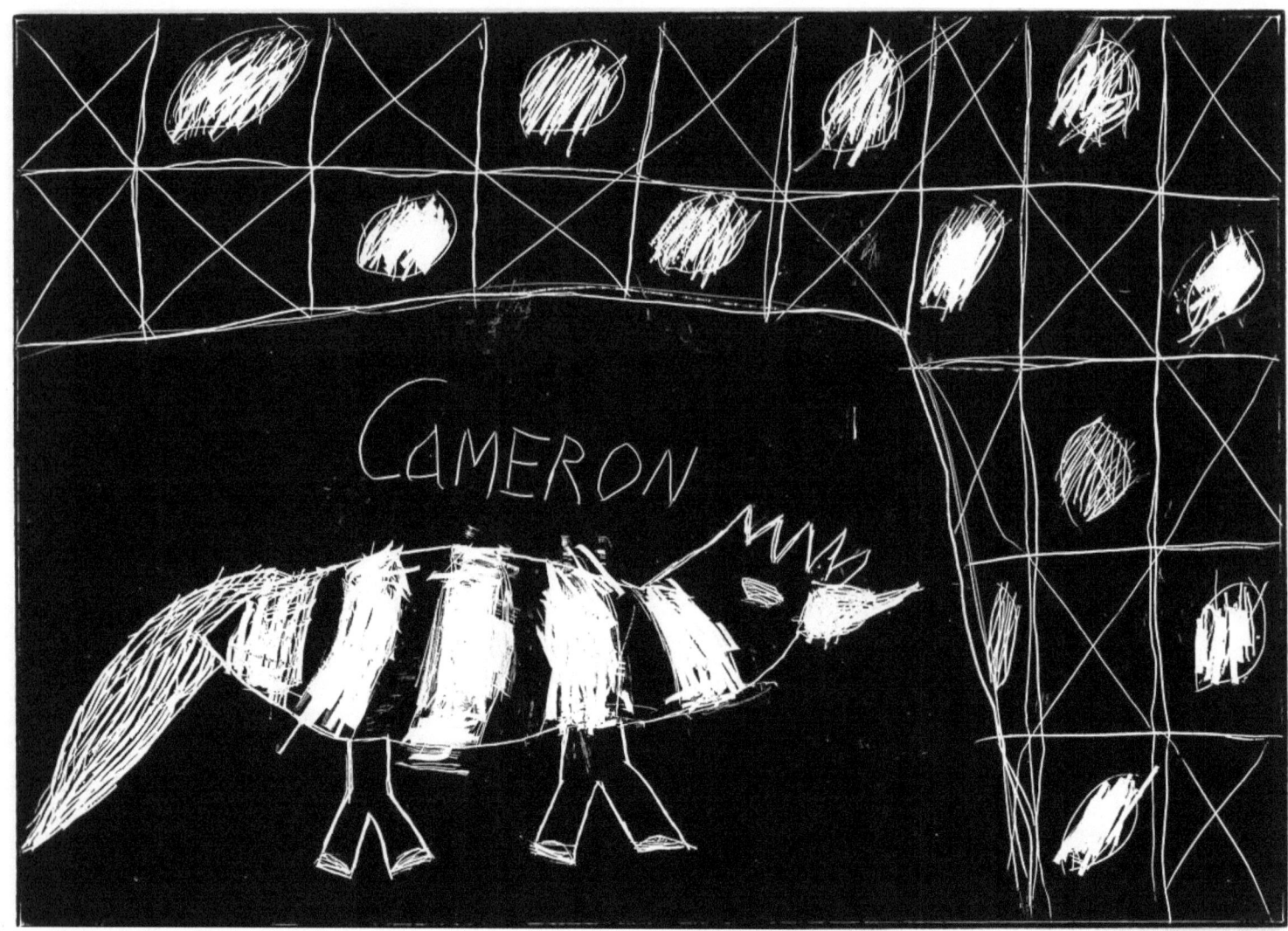

Figure 8: *Tic Tac Lizard*, Scratchboard, 2012, 5"x7", Cameron Humphreys

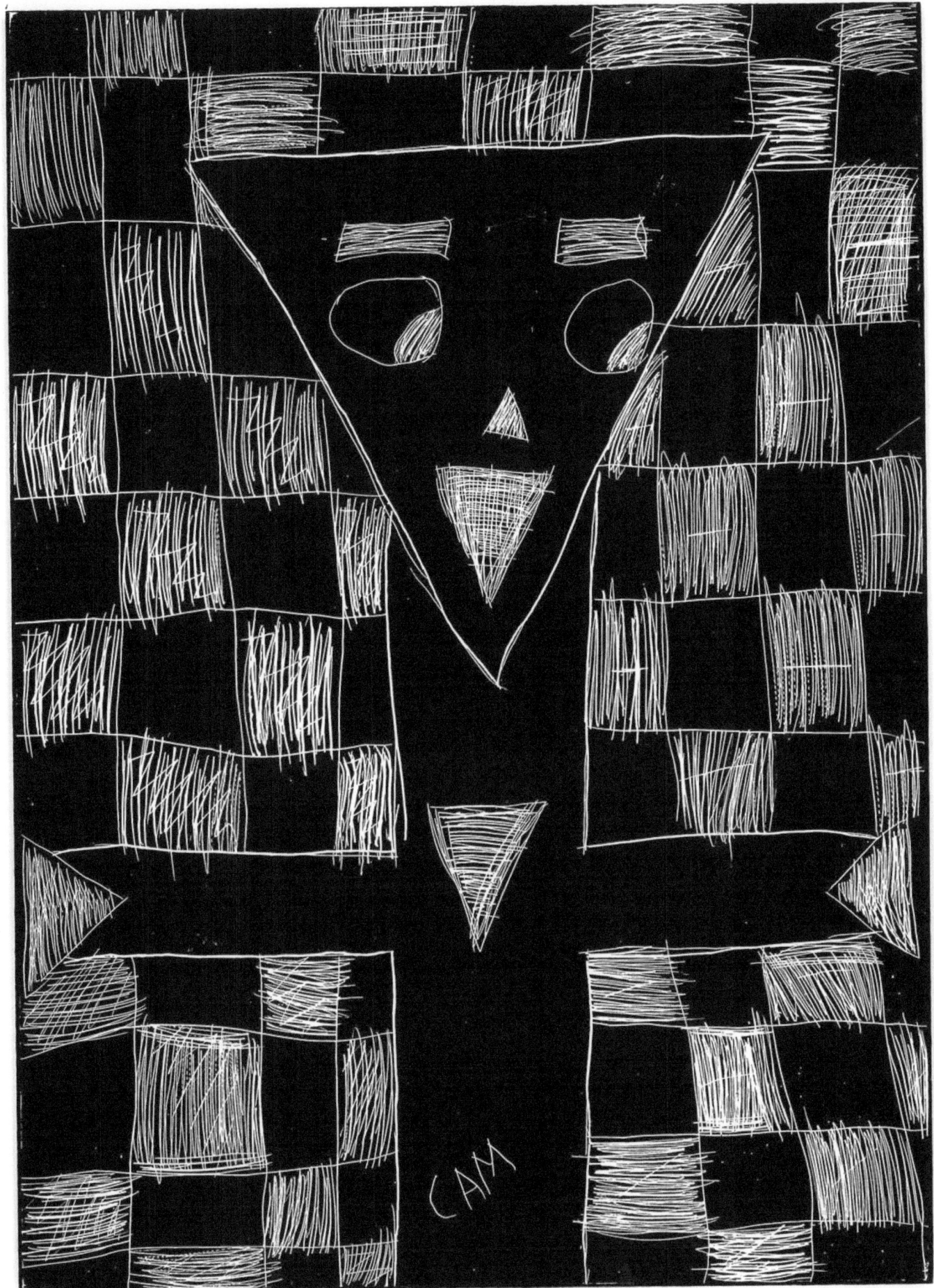

Figure 9: *Mr Triangle Man*, Scratchboard, 2012, 5"x7", Cameron Humphreys

CHAPTER 3: TOYS, TOYS, TOYS!!!

Who doesn't love toys? Since the birth of my son, Cameron, in 2002, I have begun collecting toys bordering upon obsession! I have many, many toys. I probably have close to a thousand with that number increasing sometimes daily. I pick up toys whenever I find a deal. I frequent the Goodwill Thrift Shop, Salvation Army Retail Store, second hand stores, garage sales, flea markets, etc. I use the toys to set up still lives with them, but to me they are not "still." To me they are a living entity that deserves as much attention as a portrait. To my son, they are companions in his world of play.

I collect bendable toys, Fisher Price toys, action Figures, etc. Whatever makes a good composition for my scratchboards. One type of toy I am particularly fond of are the bendable toys made in 1968 for the Colorforms Company, by designer Mel Birnkrant. These toys were called the "Outer Space Men." Seven Figures made up this line, each corresponding with the planets of the solar system. These toys were very expensive. A complete set of them can be found on Ebay for about $5000! It goes without saying I don't own a perfect set. After all, I am just a "starving artist!" Figure 10: _Colossus Rex_ is one of these coveted Figures. In this image I combine words with the image, a technique I have been employing in my other artwork as well. Figure 11: _Alpha 7_ is another example of this sentiment. The last image I did of the Outer Space Men, Figure 12: _My Outer Space Men_ is an image that contains all the Figures that I own. Not perfect ones, for example, the Figure Astro Naultililus, I only have the head…better than nothing!

The next set of images include Fisher Price toys, mainly pull toys, the old wooden variety. Once again, I do not own perfect ones, but very used ones that have a well loved look. Figure 13: _Dog Pull Toy, Train, and Play Camera_ is a good example of this. This scratchboard contains inanimate toys but to me they are very much alive! The next image, Figure 14: _Telephone, Play Camera and Play Radio_ is another example. These are not inanimate objects but look like they could "jump off the page!" The next scratchboard, Figure 15: _Jalopy Car_ is a close up view of this toy; a child's view of the toy. The next toy is another pull toy, this one being a tractor with a wagon, Figure 16. These are not toys you can find today new, most of them come from the 50s-80s. the last Fisher Price pull toy I did is one from the 1950's, Peter Pig. This toy I purchased at the Antique Festival in Midland, MI. It is not a toy in pristine condition, but it is "perfect" to draw. It has much "character." I did several versions of this toy. Figure 17, 18, and 19 are examples of this sentiment.

The next set of images are just random arrangements of toys in a still life. Figure 20: _Fond Memories_ showcases this sentiment. This scratchboard contains two Fisher Price radios, a plastic basketball player that shoots the ball when you press on his head, a soft Pillsbury Dough Boy and an android robot figure. Figure 21: _Wind Up Plastic Robot and Die Cast Car_ is a smaller version of a random arrangement of toys. Figure 22: _Tin Bear, Weinerschnitzel Burger, and Clown Nathan Hotdog_ are three unrelated toys. But are they unrelated? Not to me, not to Cameron. The next 2 images, Figure 23 and 24, are 2 versions of an arrangement of unrelated Figures: A Cabbage Patch Doll and Alfred E. Neuman as Batman. One version is 7"x5" and the other is 10"x8". Both sizes "work."

The last set of images in this chapter are not "toys" in the classical sense. They are puppets. Puppets, after all, are toys that are designed to be "animated." While in graduate school at WMU I had the fortunate luck to be able to travel to Bali, Indonesia. It was amazing! While there, I saw a puppet show. It was called "Wayang Kulit." These puppets were created on carved leather, painted and mounted on a wooden stick. Figure 25 and Figure 26 are examples of this. These puppets are not Balinese, but rather Javanese. Much more information is available on the puppets

from Java. Since I did these scratchboards, I have obtained Balinese shadow puppets (as of yet I have not done any scratchboards of the Balinese versions.)

The last four scratchboards in this chapter are ones of unusual puppets. Talk about "character!" The puppets are overflowing with attitude. Figures 27 and 28 are two versions of the same image, one is 7"x5" and the other one is 10"x8". They are of one puppet looking at another puppet in the mirror. The final two images, Figure 29 and 30 are basically the same puppet; a puppet of a half naked woman that "screams" with attitude. You can almost hear her say "DON'T MESS WITH ME!"

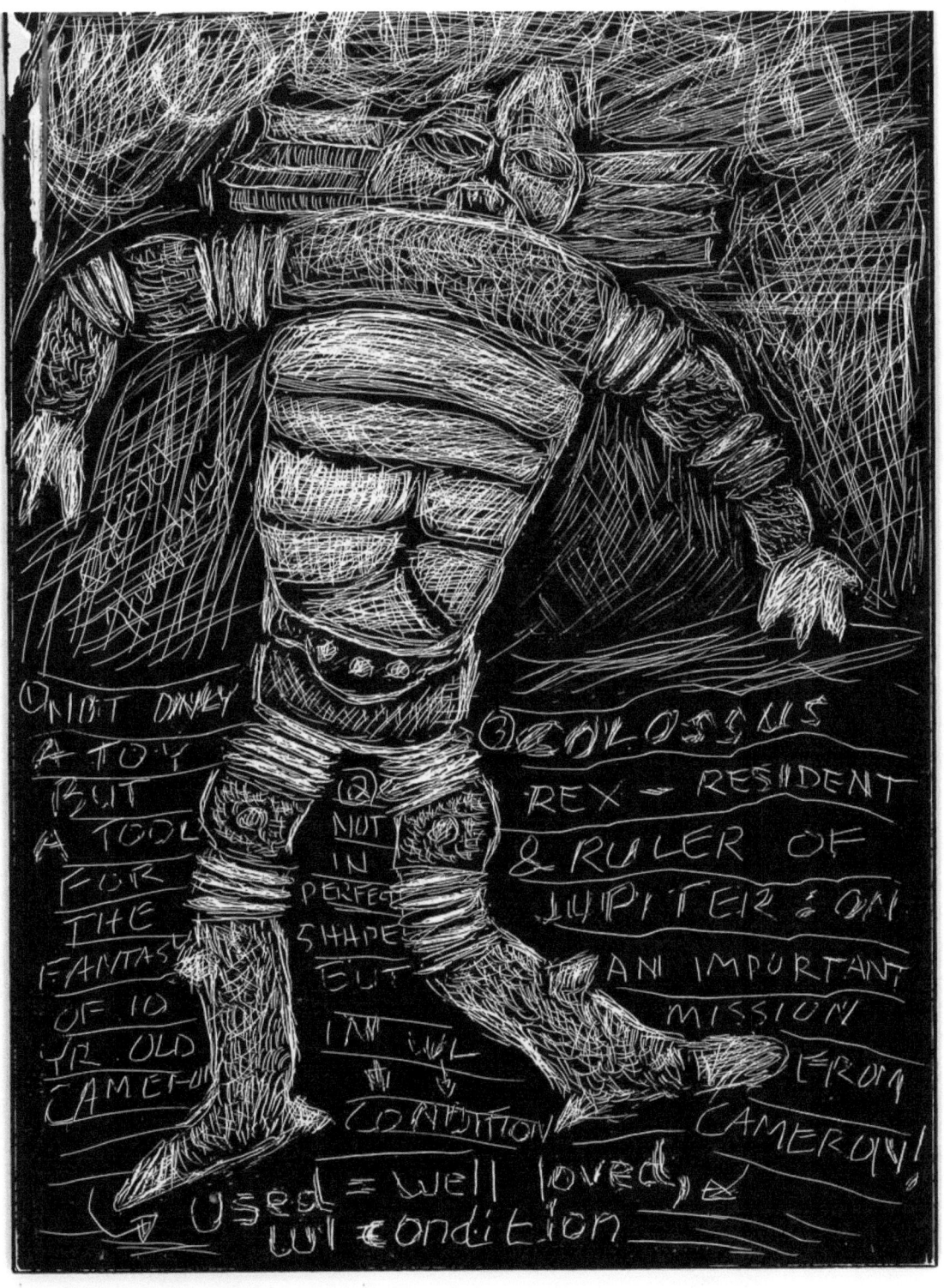

Figure 10: *Colossus Rex,* Scratchboard, 2012, 5"x7", Patrick Humphreys

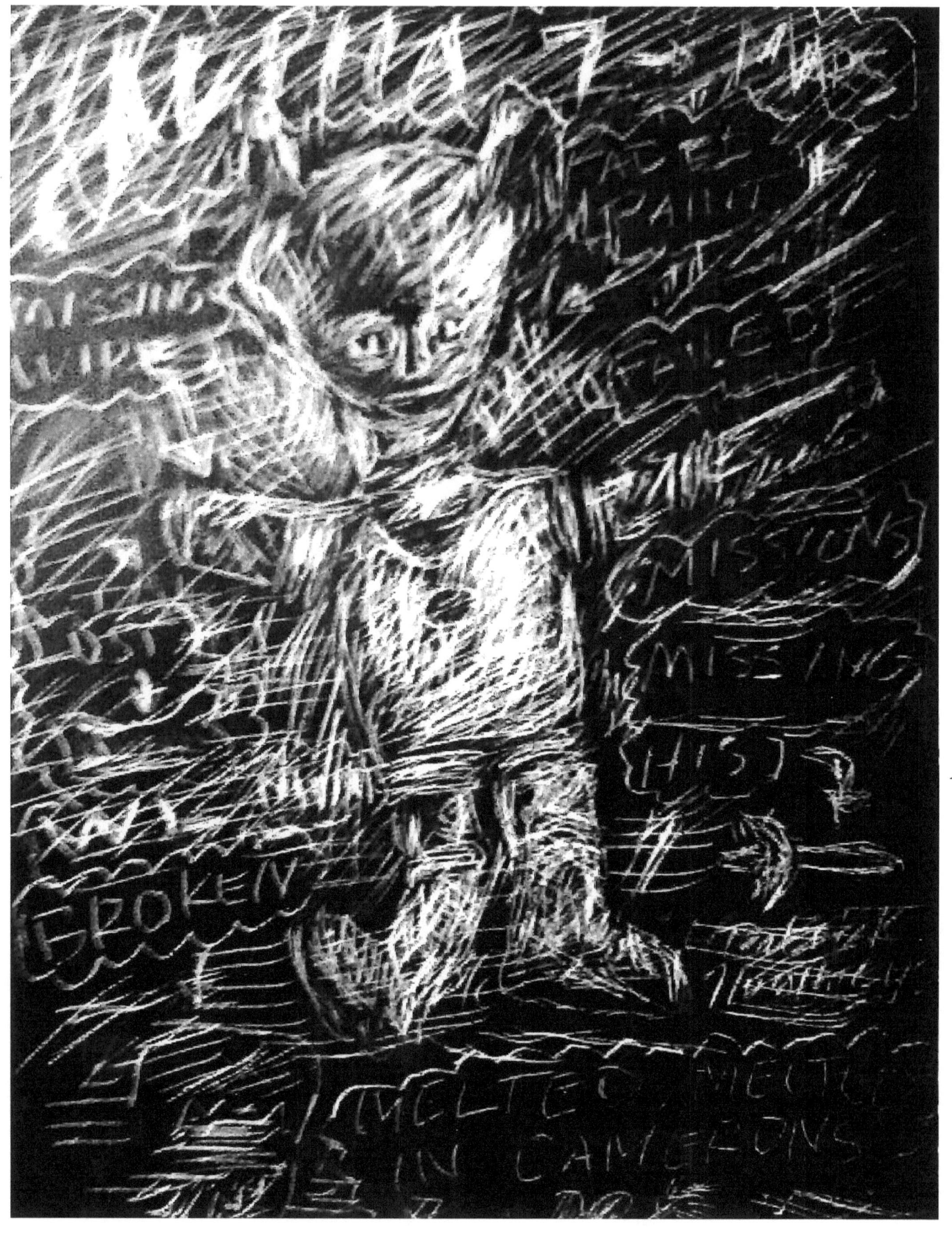

Figure 11: *Alpha 7*, Scratchboard, 2012, 5"x7", Patrick Humphreys

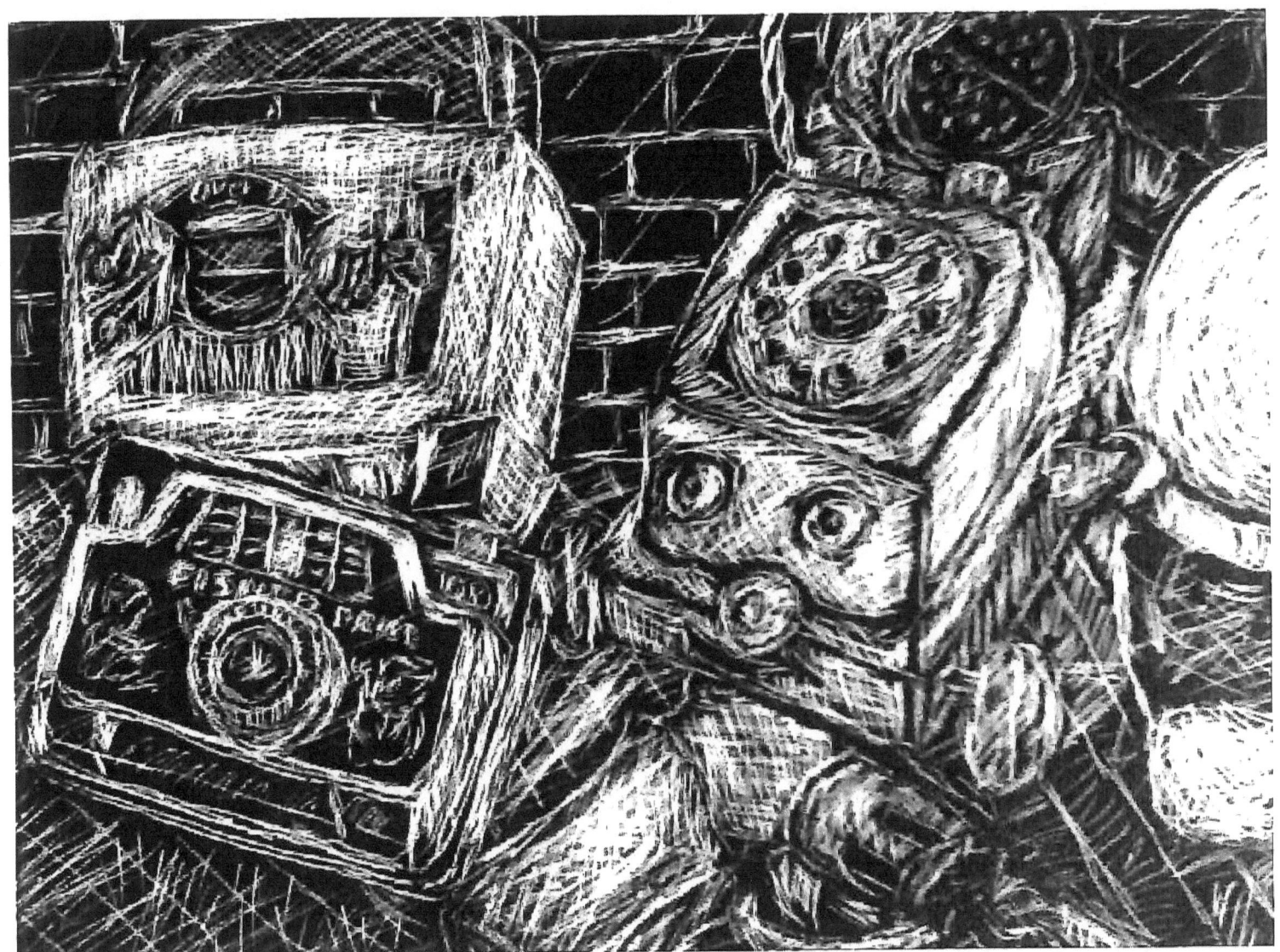

Figure 14: *Telephone, Play Camera and Play Radio,* Scratchboard, 2012, 5"x7", Patrick Humphreys

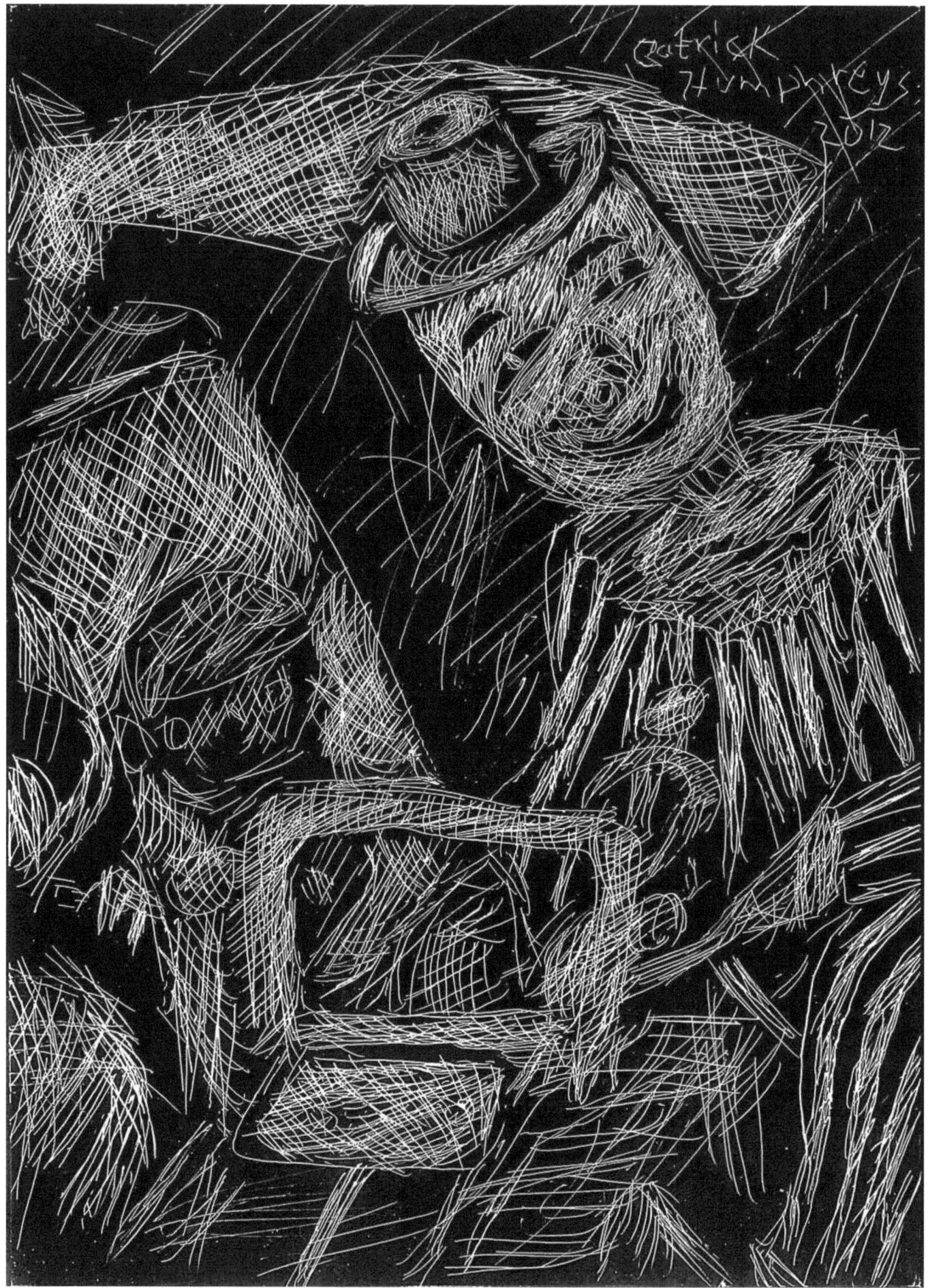

Figure 15:*Jalopy Car*, Scratchboard, 2012, 5"x7", Patrick Humphreys

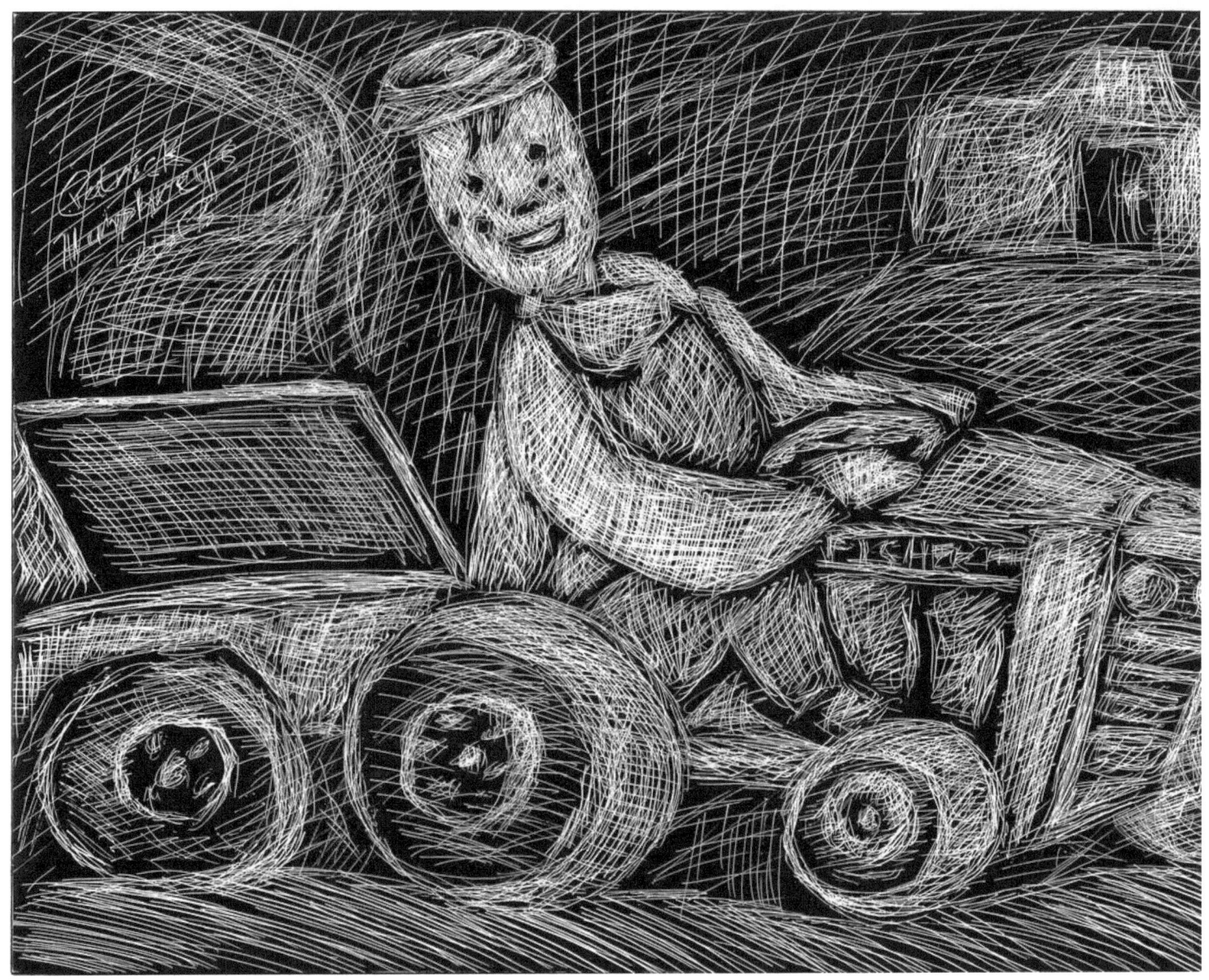

Figure 16: *Fisher Price Tractor Pull Toy with Wagon*, 2012, 10"x8", Patrick Humphreys

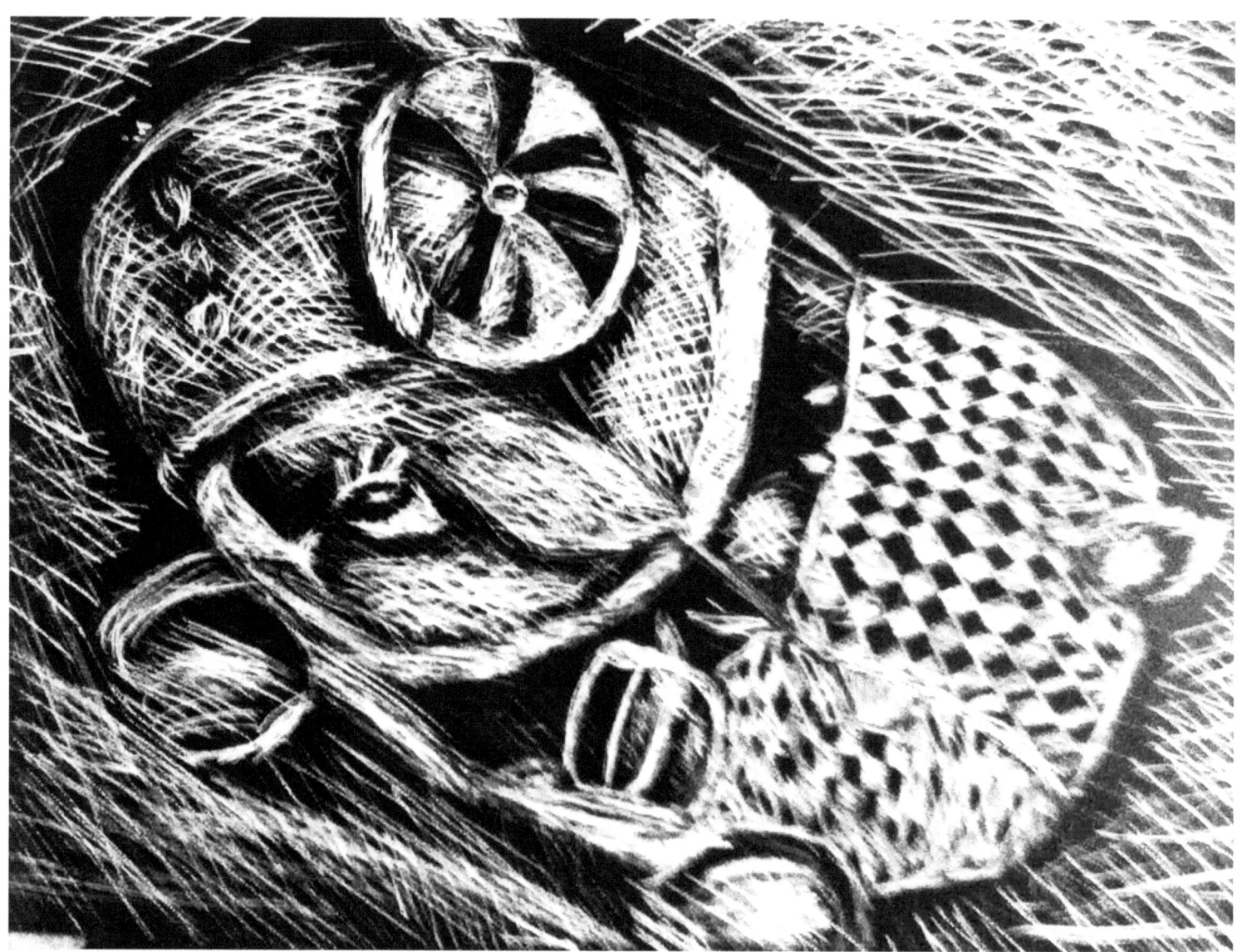

Figure 17: *Peter Pig Pull Toy, Version One*, Scratchboard, 2012, 8"x10", Patrick Humphreys

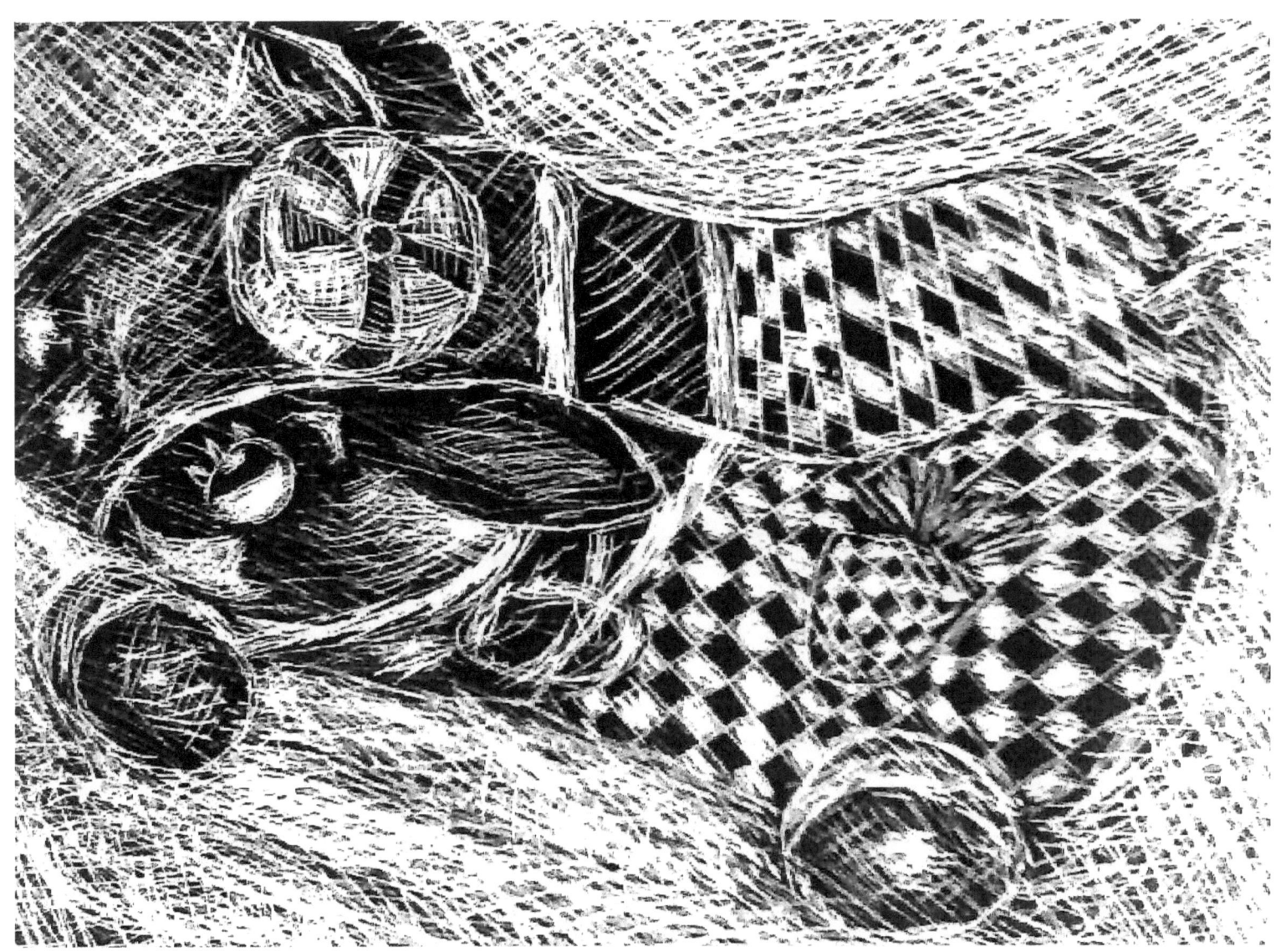

Figure 18:*Peter Pig Pull Toy, Version Two*, Scratchboard, 2012, 8"x10", Patrick Humphreys

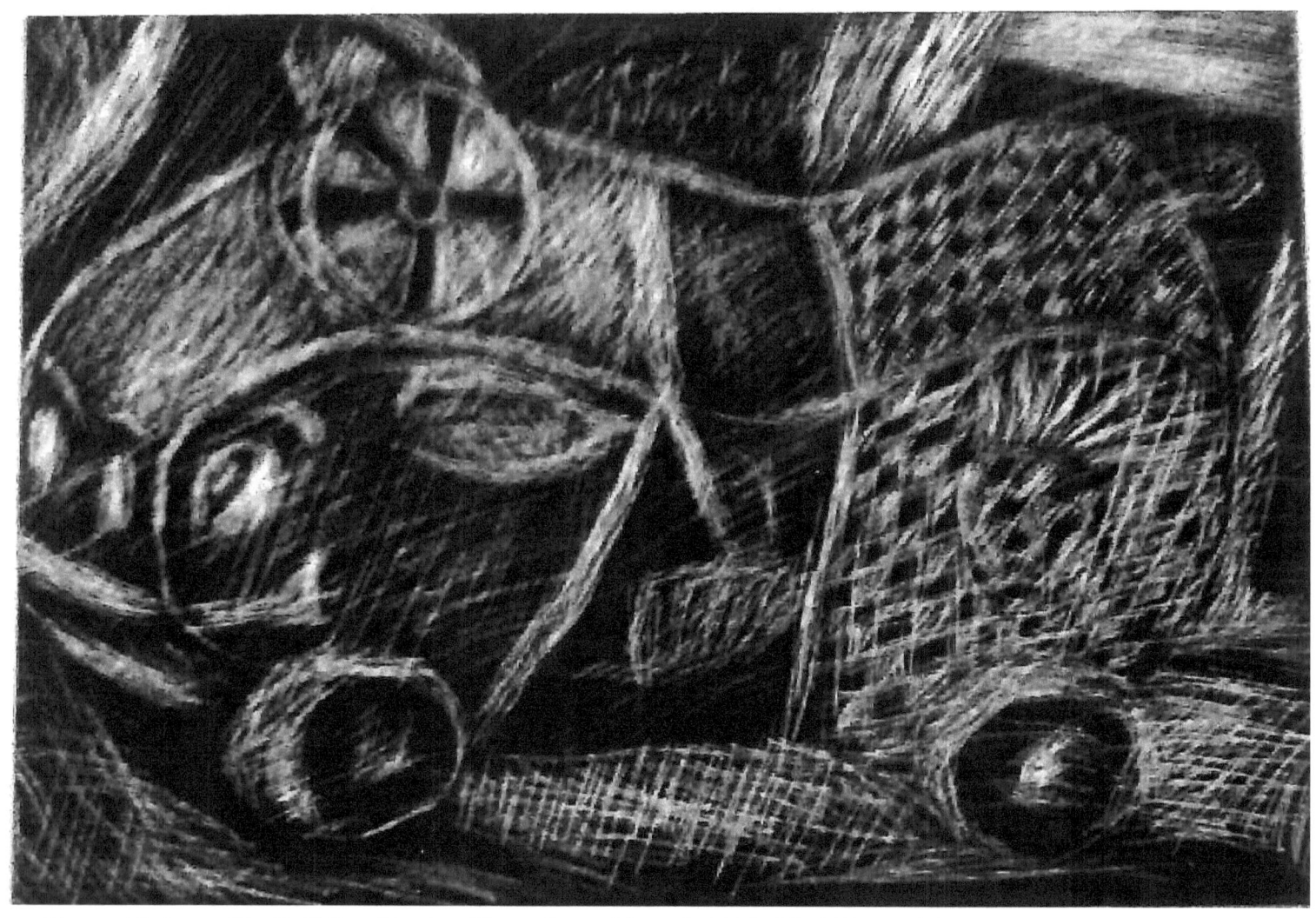

Figure 19: *Peter Pig Pull Toy, Version Three,* Scratchboard, 2012, 8"x10", Patrick Humphreys

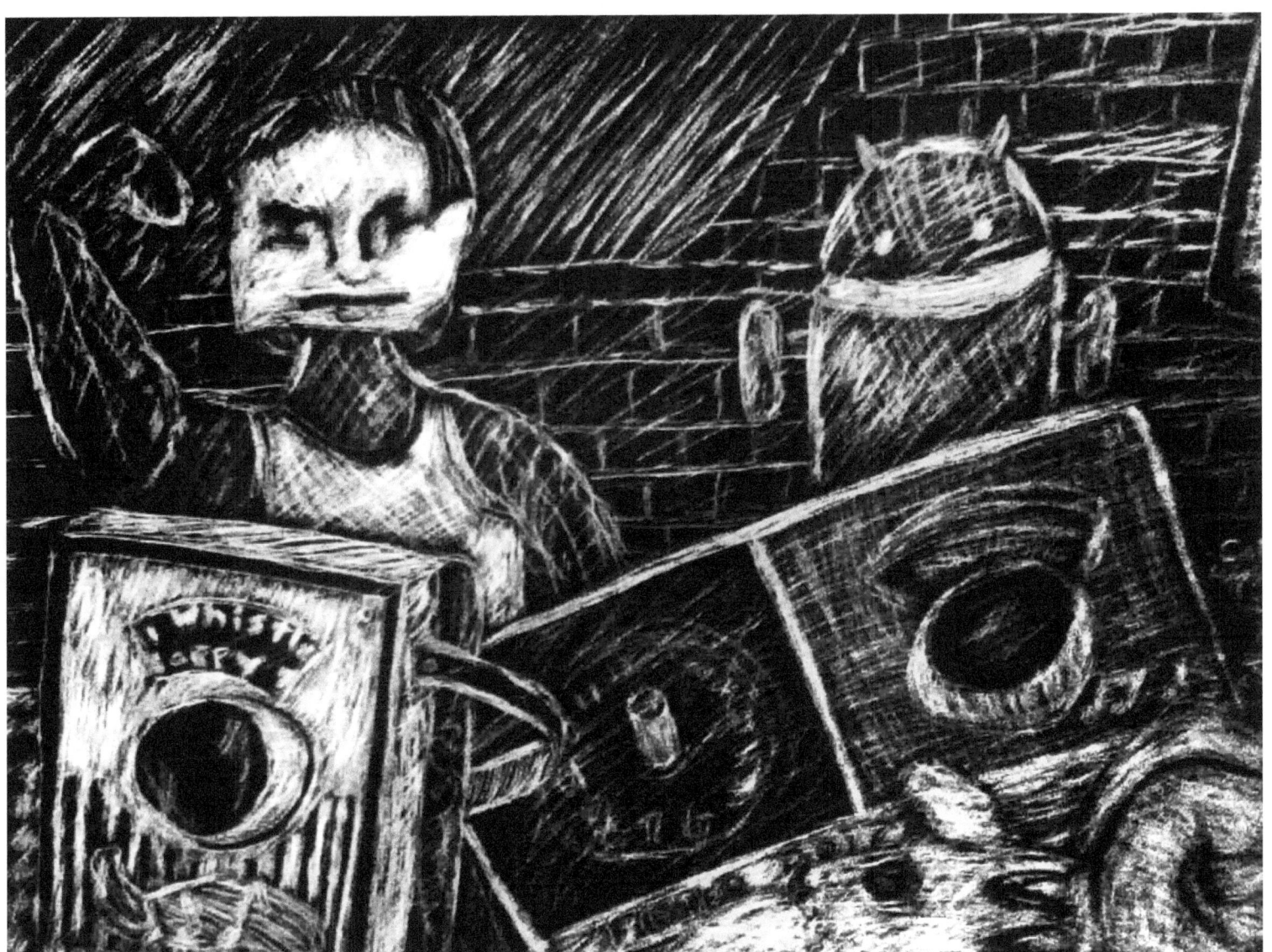

Figure 20: *Fond Memories,* Scratchboard, 2012, 5"x7", Patrick Humphreys

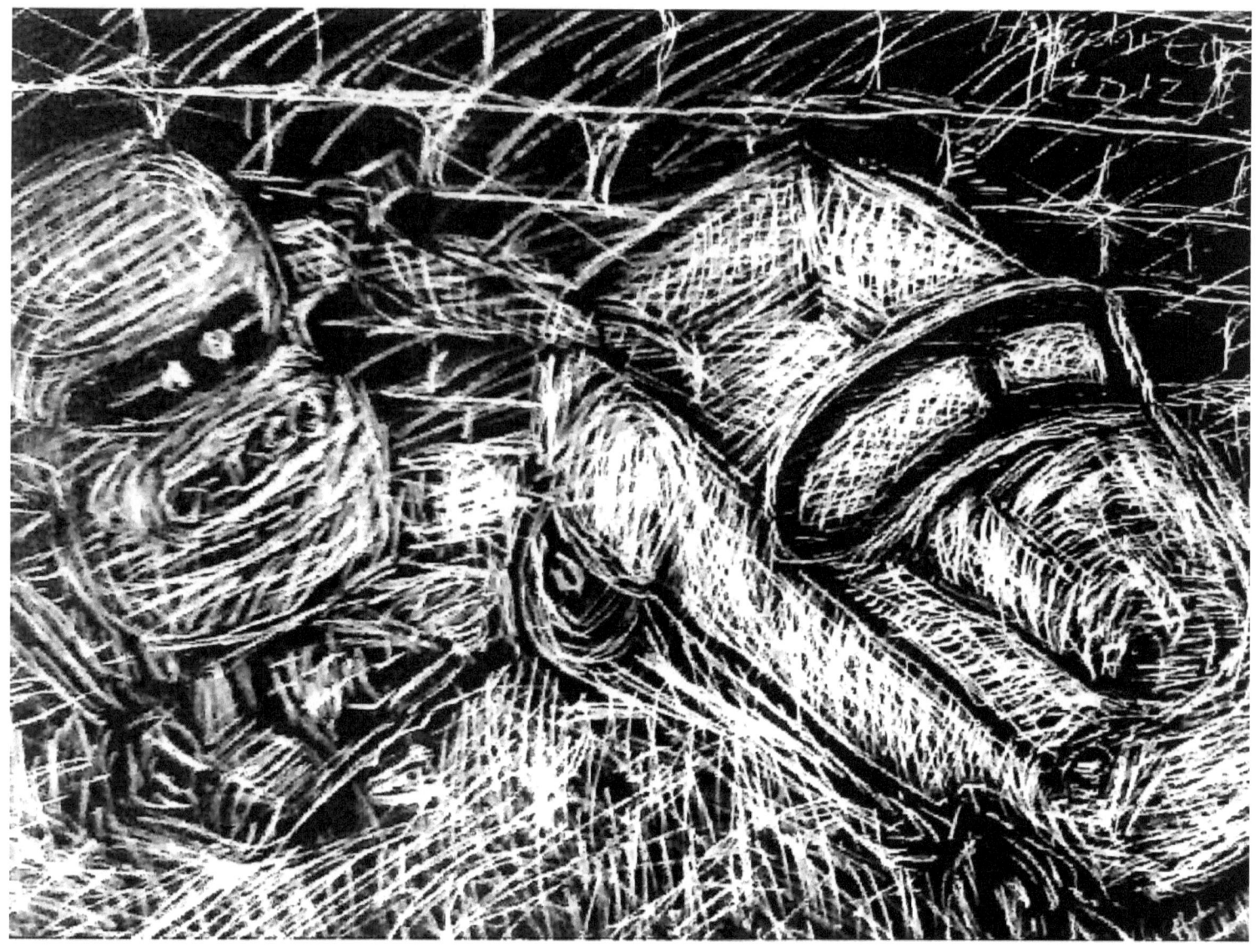
Figure 21: *Wind Up Plastic Robot and Die Cast Car,* Scratchboard, 2012, 5"x7", Patrick Humphreys

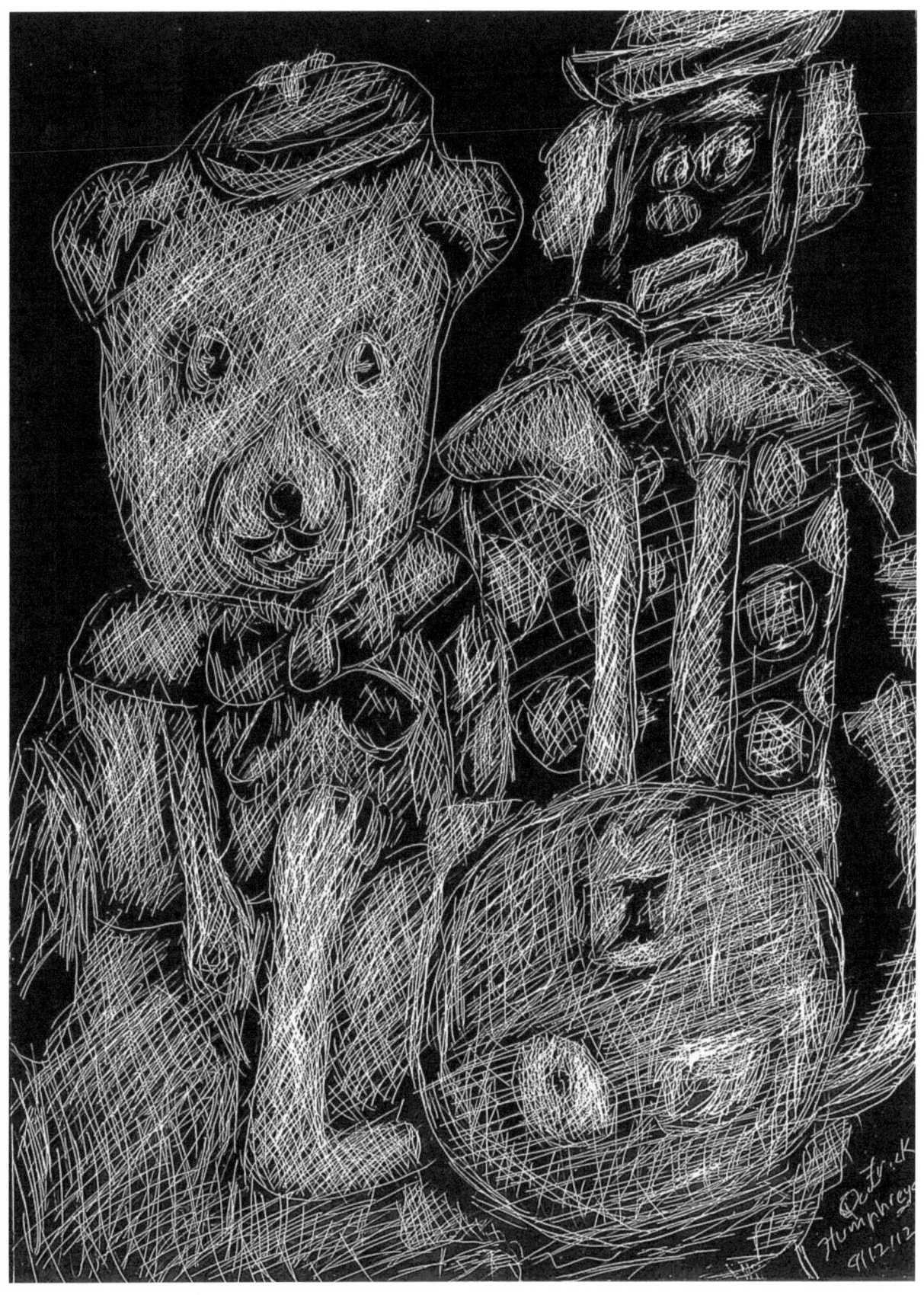

Figure 22: *Tin Bear, Weinerschnitzel Burger, and Clown Nathan Hotdog*, Scratchboard, 2012, 5"x7", Patrick Humphreys

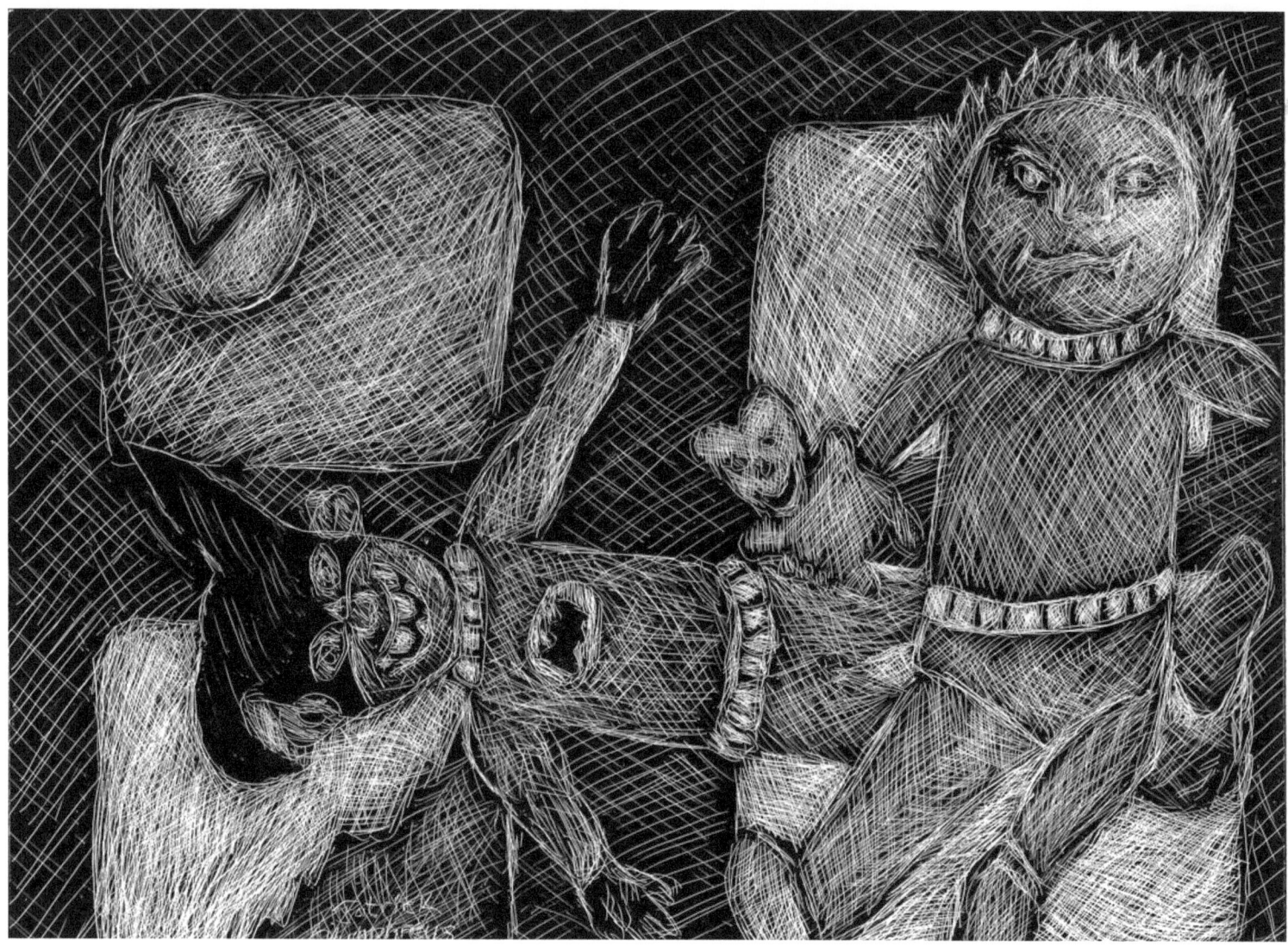

Figure 23: *Cabbage Patch Doll and Alfred E Neuman as Batman,* Scratchboard, 2012, 7"x5", Patrick Humphreys

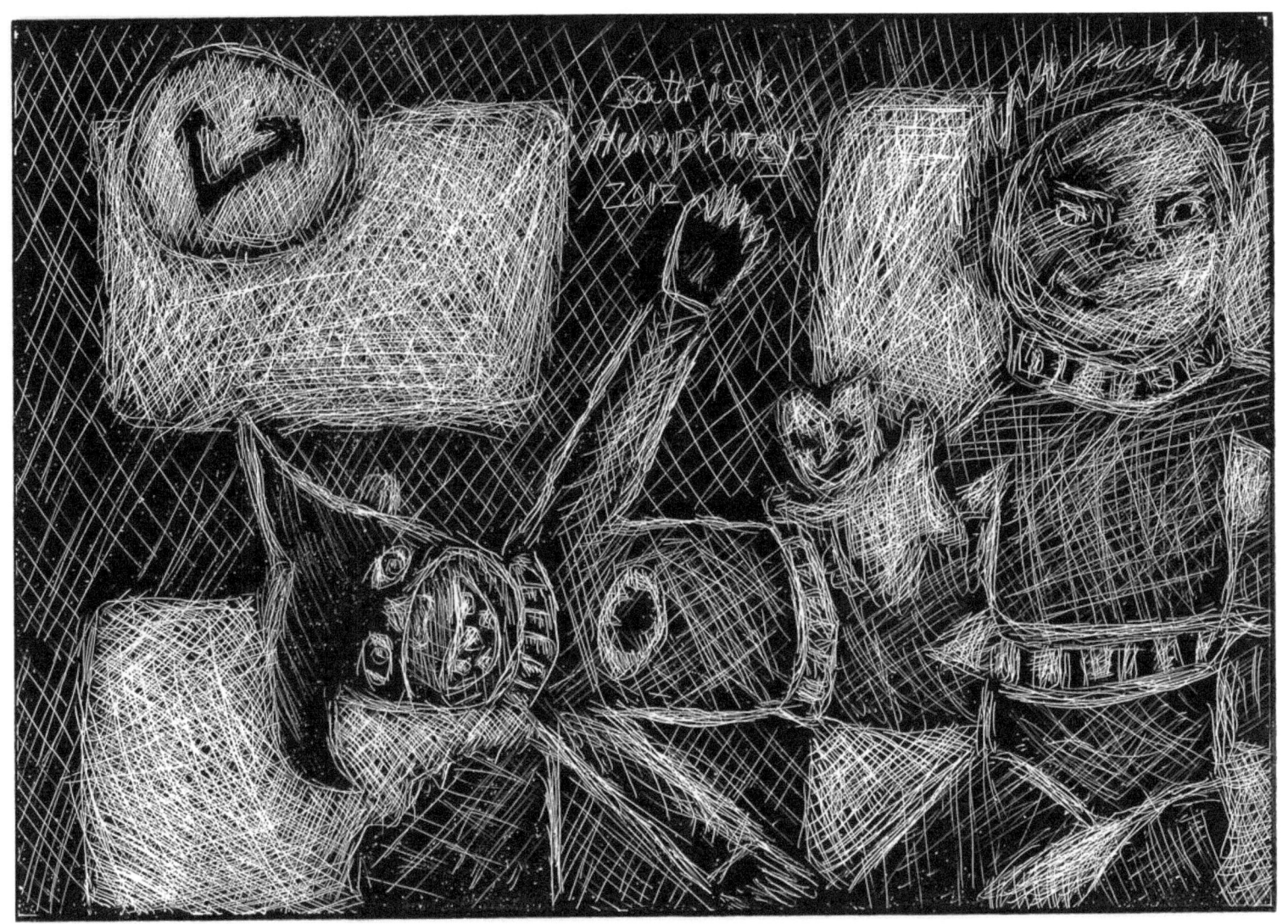

Figure 24: *Cabbage Patch Doll and Alfred E Neuman as Batman Version 2,* Scratchboard, 2012, 7"x5", Patrick Humphreys

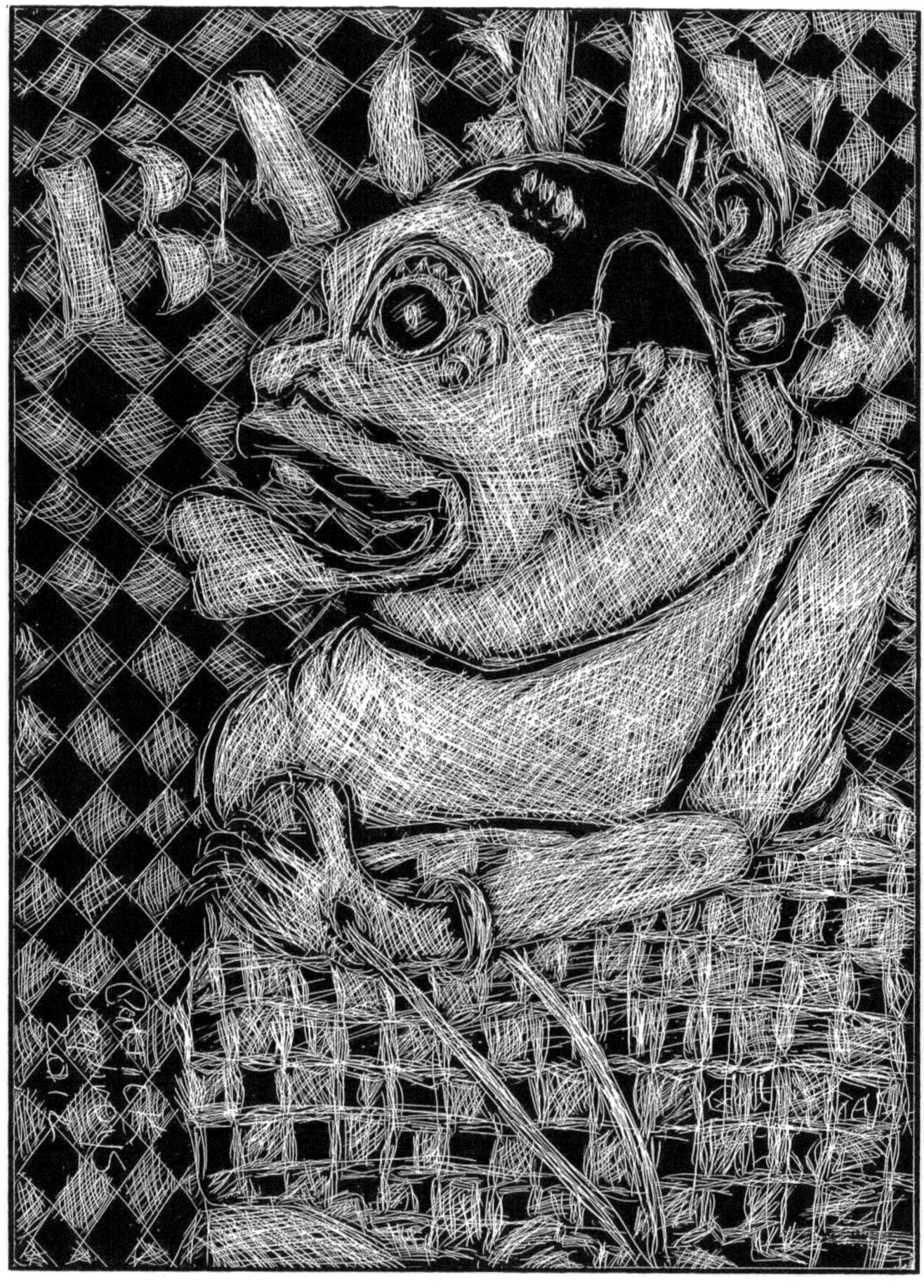

Figure 25: <u>*Javanese Shadow Puppet: Bagong,*</u> Scratchboard, 2012, 7"x5", Patrick Humphreys

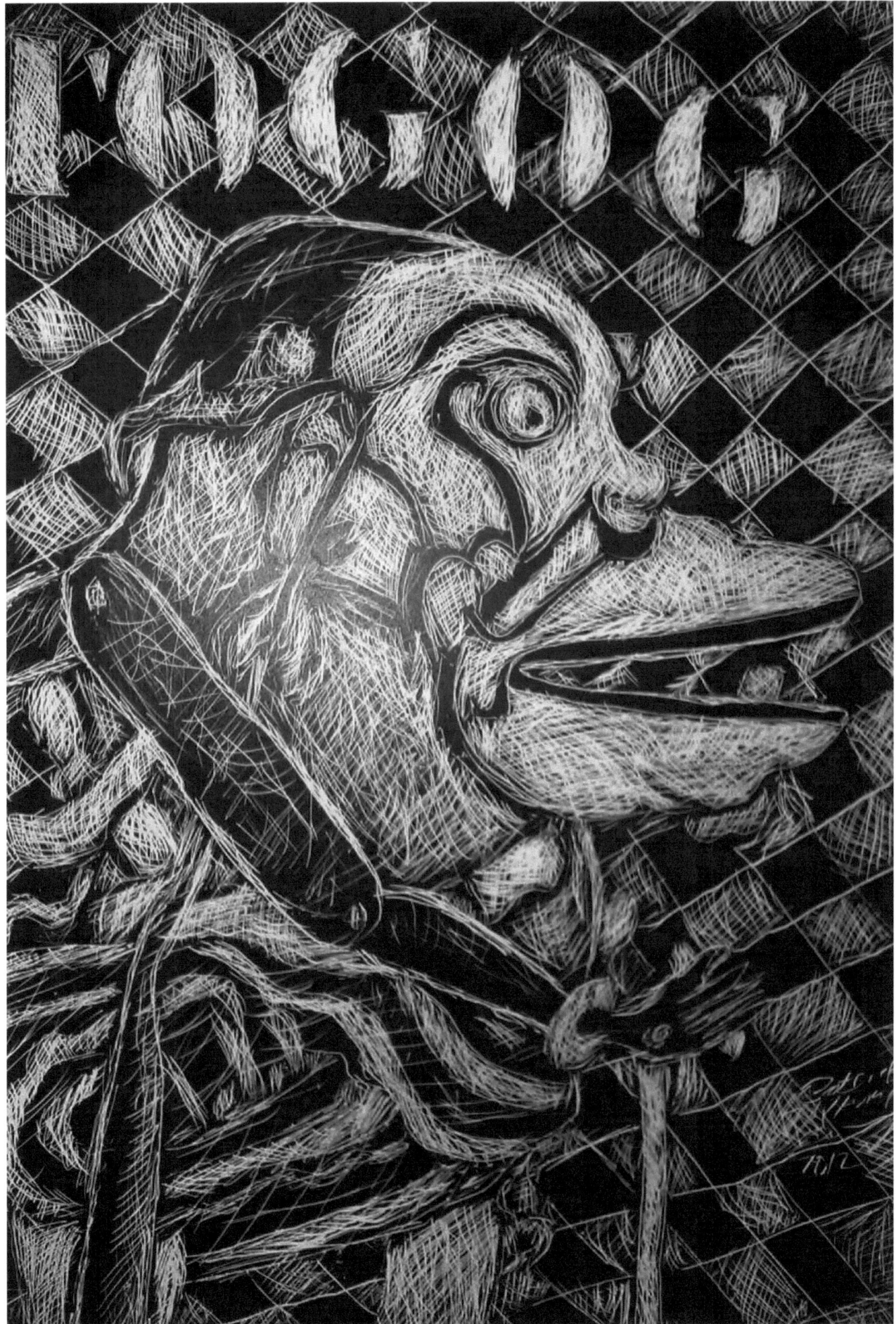

Figure 26: *Javanese Shadow Puppet*: <u>Togog.</u> Scratchboard, 2012, 8"x10", Patrick Humphreys

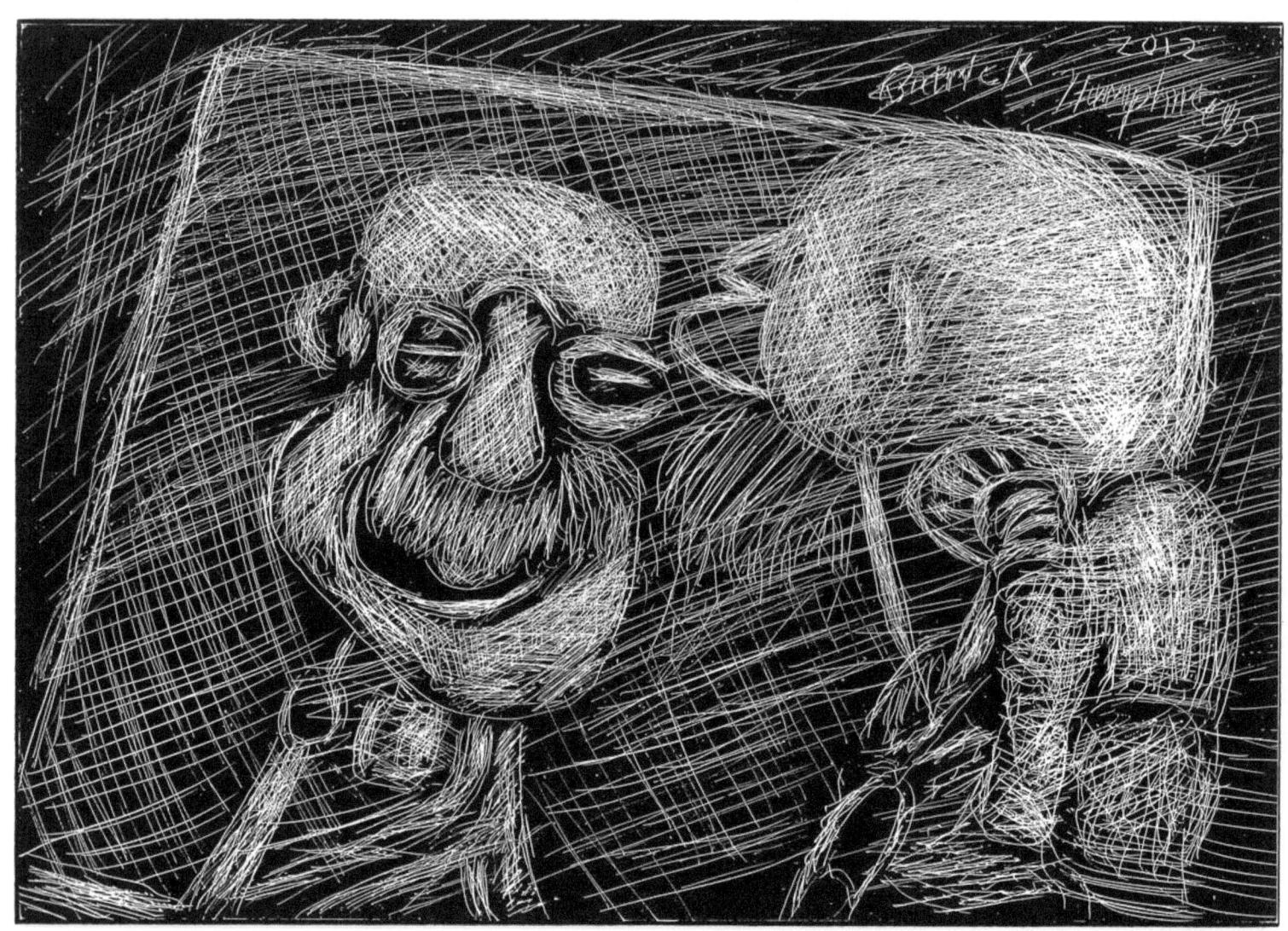

Figure 27: *You Looking at Me?,* Scratchboard, 2012, 10"x8", Patrick Humphreys

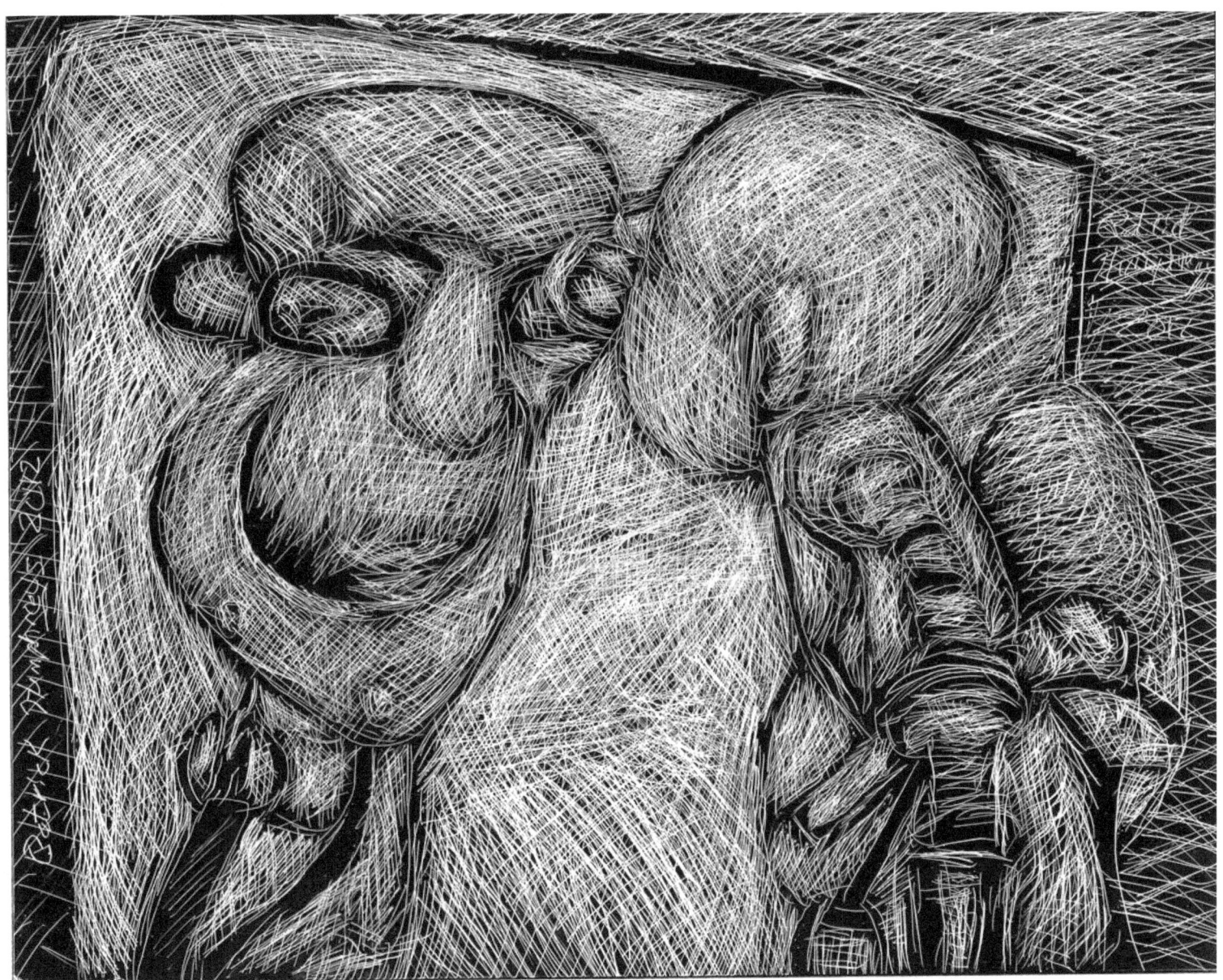

Figure 28: *You Looking at Me? Version Two,* Scratchboard, 2012, 5"x7", Patrick Humphreys

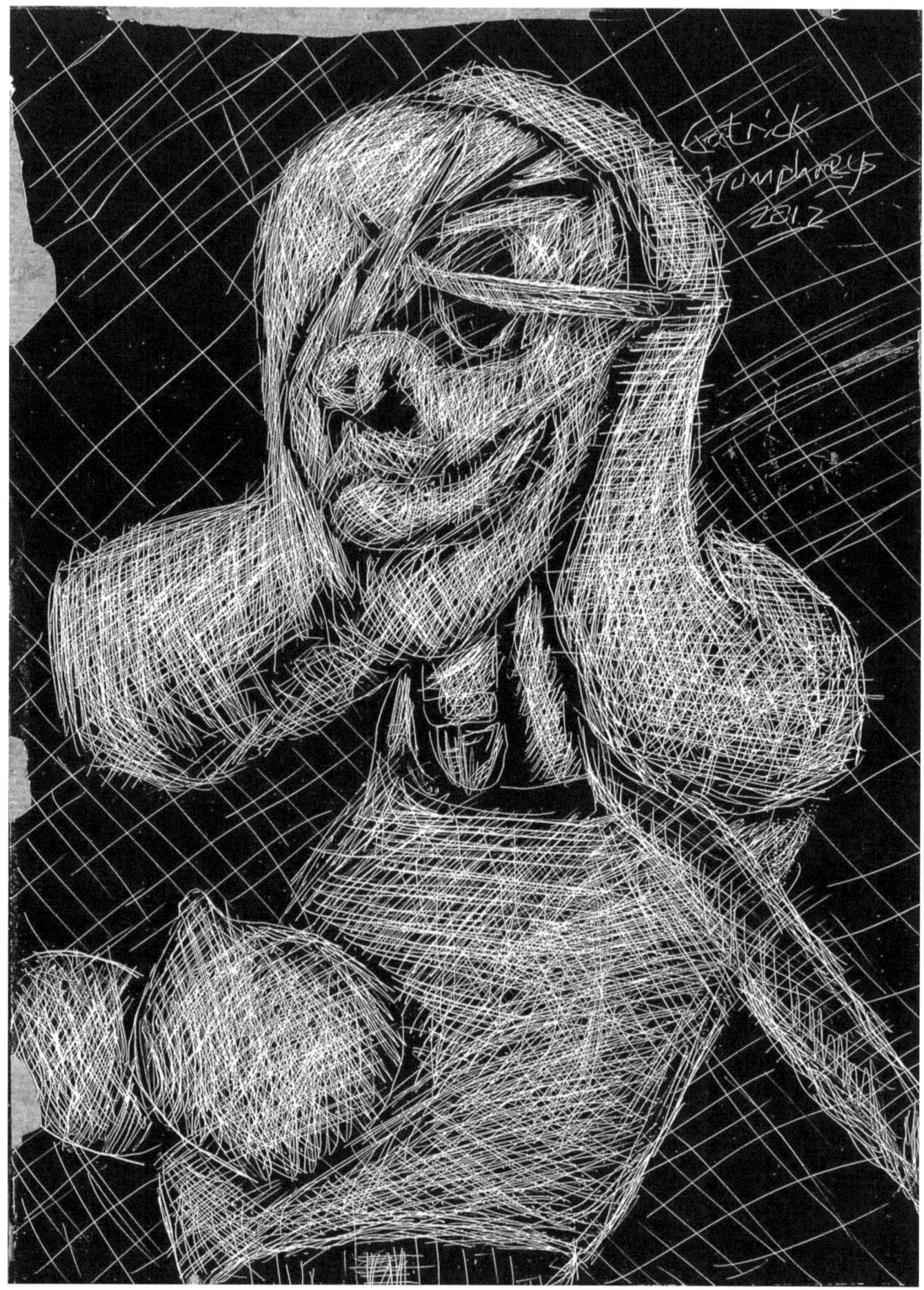

Figure 29: *Don't Mess With Me!,* Scratchboard, 2012, 5"x7", Patrick Humphreys

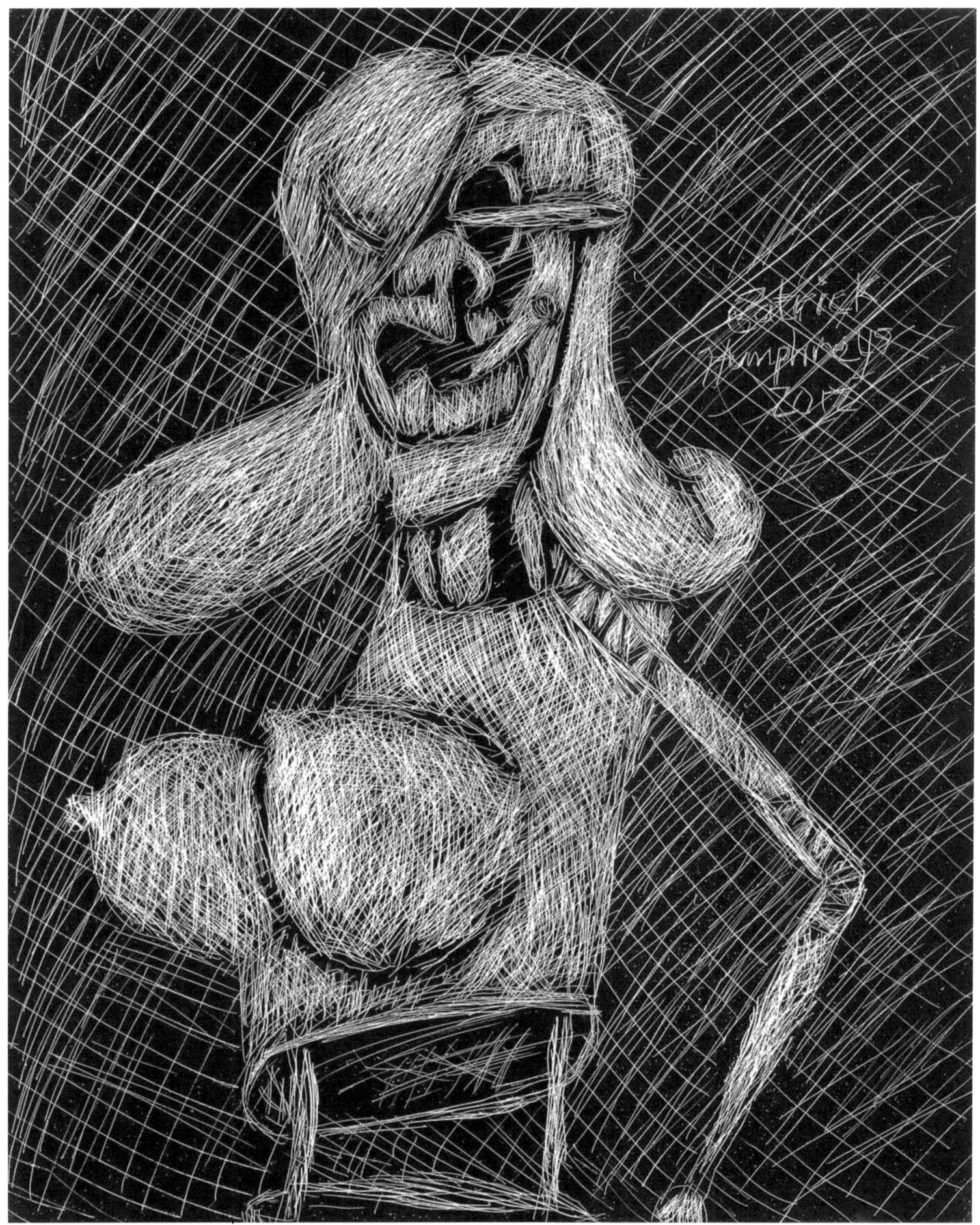

Figure 30: *Don't Mess With Me Version 2,* Scratchboard, 2012, 8"x10", Patrick Humphreys

CHAPTER 4: ANIMALS

 This chapter is about scratchboards I did of animals, including one of a dissected squirrel. I wanted to be a medical illustrator at one time. My fascination with animals started at an early age while growing up, my home was occupied with pets. We had a couple of dogs, but mainly cats were our animal of choice.

 The squirrel on tree, scratchboard on paper is the logical choice to begin with in this chapter. This image, Figure 31 is my oldest surviving scratchboard. It may have been done over 25 years ago, but it is still a "fresh" picture today. It was done in high school, completed in 1987. Speaking of squirrels, Figure 32, *Cut Away Squirrel,* is the next image. If I love animals, then why do an image of a killed and mutilated animal? This image pays homage to several things. It is a direct influence with my one time desire to be a medical illustrator, but also is homage to several of my favorite contemporary artists, Francis Bacon and Chaim Soutine. These artists did paintings that focused on dissected animals, including pigs, cows and chickens. There is a beauty in ugliness and life in death! While in graduate school at WMU I took several trips to the Art Institute of Chicago. On view there is the Francis Bacon painting, *Pope Surrounded by Sides of Beef, 1945*. I could stand in front of this painting for hours! The manner of which it is painted is amazing! My desire is for you the viewer to experience this same desire while viewing my scratchboards, in particular *Cut Away Squirrel.*

 The next series of scratchboard are done of my favorite pets: Cats. Figure 33, *Cat in Box* is a good example of this. This image shows my cat, Maddie, in a box. Cats love boxes. This is my desire to document that as a well known fact. Figure 34, *Fluffy Cat* (I sold this particular scratch to a friend) has an intense gaze toward the viewer. Perhaps thinking: Feed me or play with me! My son Cameron also loves cats, and Figure 35 illustrates this fact. This image is more abstract paying homage to my Good Kitty images talked about previously in this book. I love this image!

 Dogs are the next subject matter of the preceding images. Figure 36, *Dog in Field* is a good example of this. This image was also sold to a friend. It is an image of a Daschound in a field. Figure 37, *Lab*, also sold to another friend, shows the playful nature of the dog: the dog tilts his head, inviting you to play with him! Come on, you know you want to!

 The last three images in this chapter are scratchboards of chickens. I find these particular birds very interesting. Figure 38 shows two birds, baby birds, in the corner of a room. They are "screaming" to be let out of the room. Could you let them out? Figure 39, a work entitled *Caged Emotions*, witnesses 3 chickens in a cage that desperately want to be let out. The last image, Figure 40, is a chicken playing with a string. Is it a string or a worm? You decide.

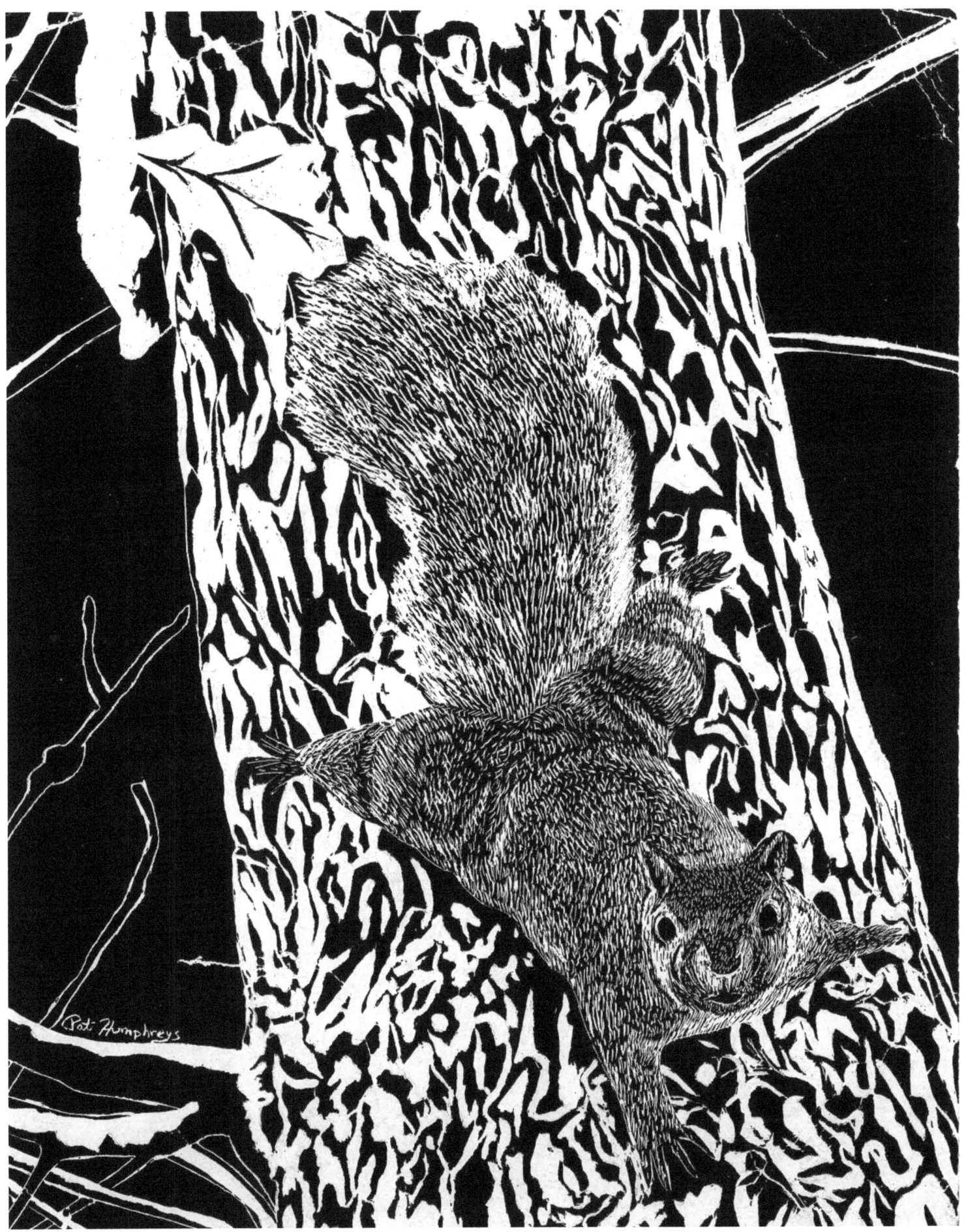

Figure 31: *Squirrel on Tree,* 8.5"x11", Scratchboard on Paper, 1987, Patrick Humphreys

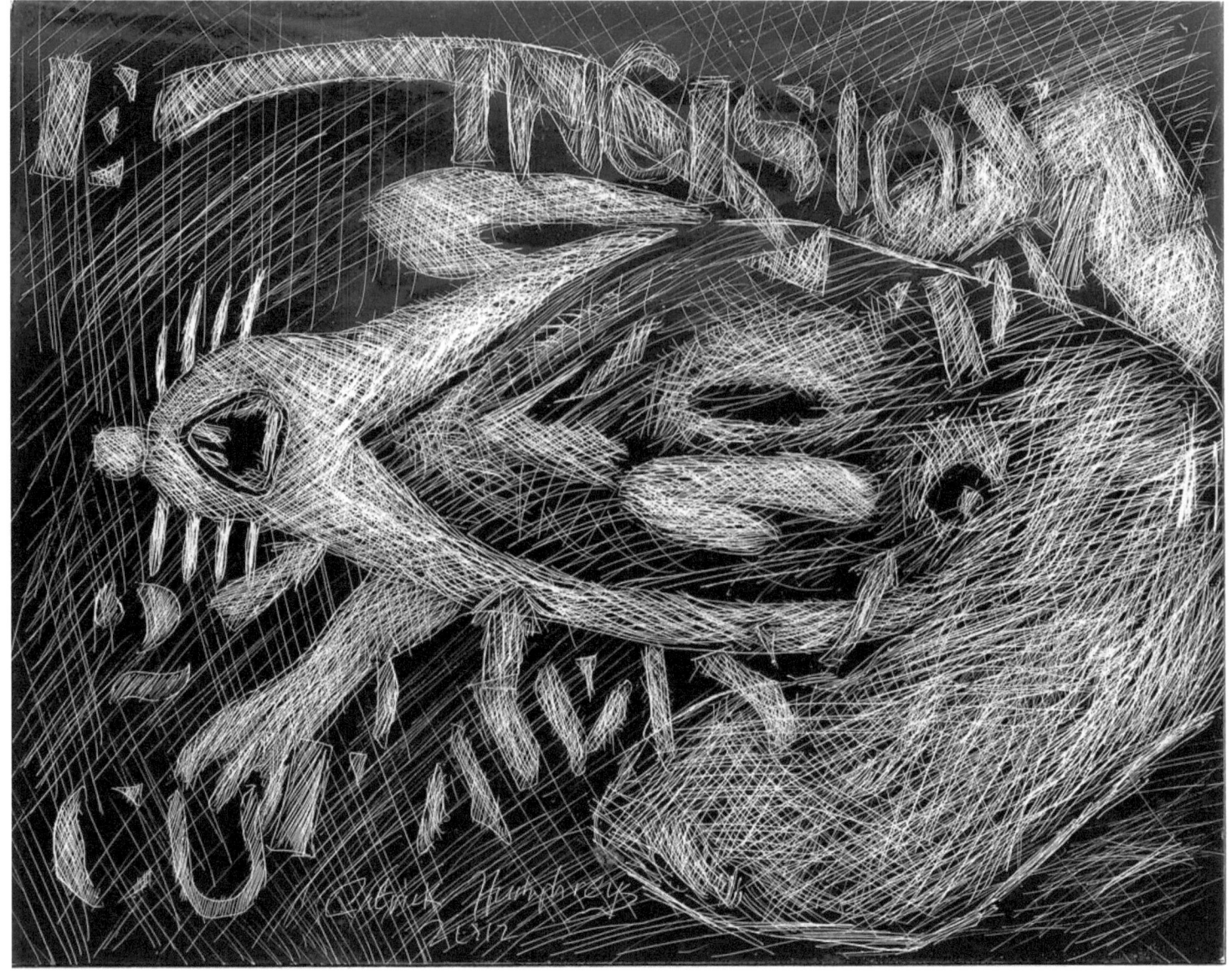

Figure 32: *Cut Away Squirrel,* 12"x9", Scratchboard, 2012, Patrick Humphreys

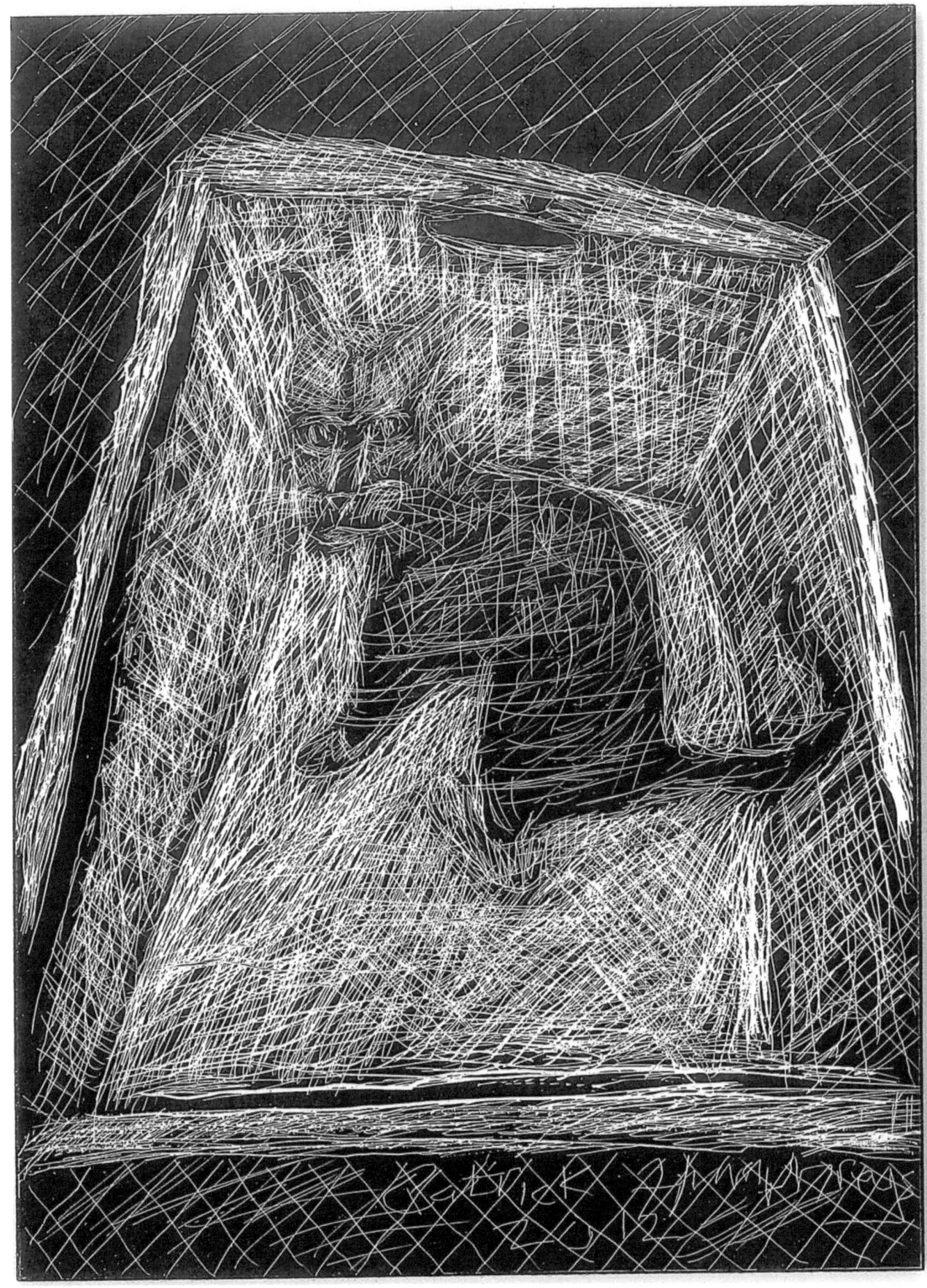

Figure 33: <u>*Cat in Box,*</u> 5"x7", Scratchboard, 2012, Patrick Humphreys

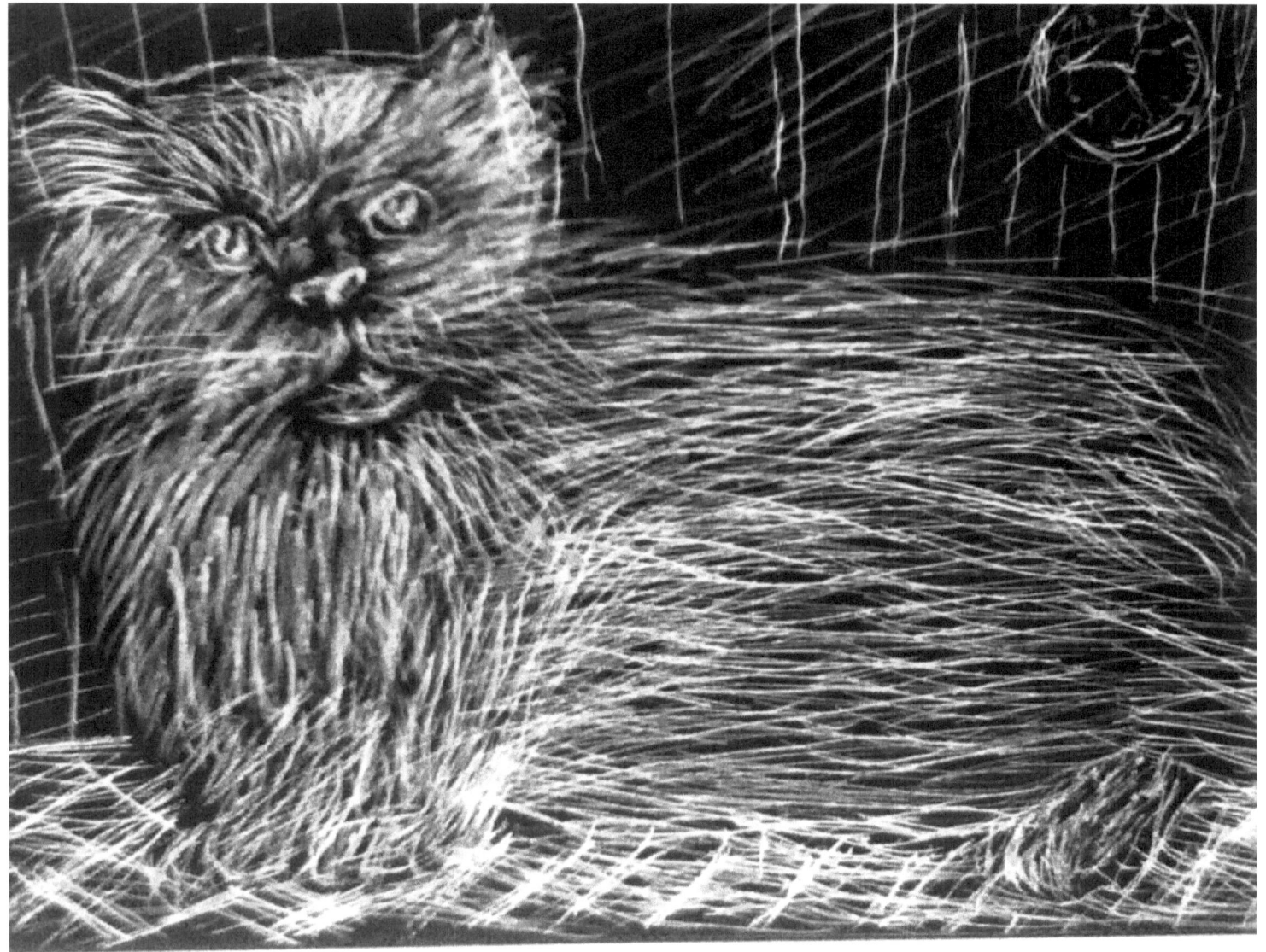

Figure 34: *Fluffy Cat,* 7"x5", Scratchboard, 2012, Patrick Humphreys

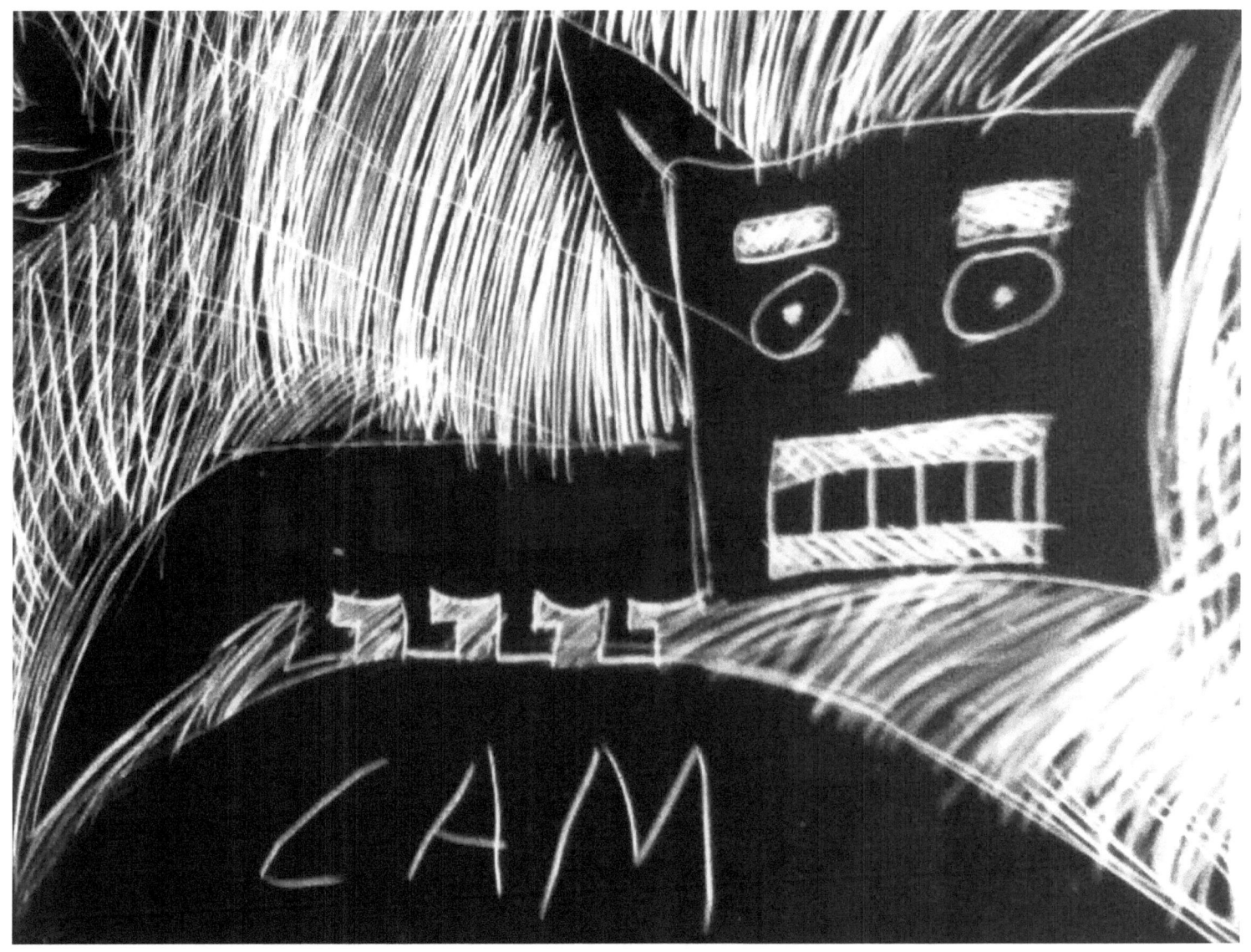

Figure 35: *Good Kitty,* 7"x5", Scratchboard, 2012, Cameron Humphreys

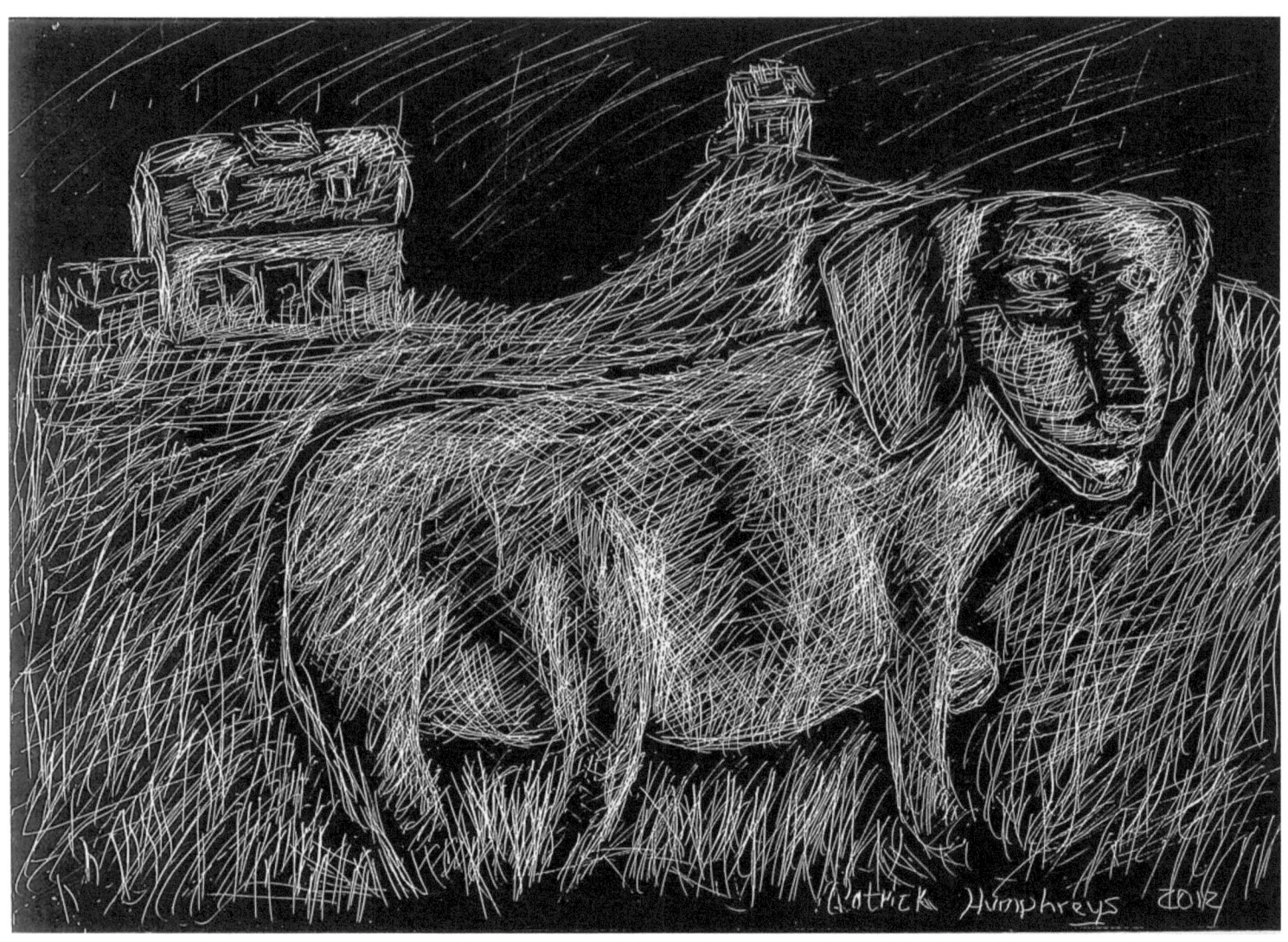

Figure 36: *Dog in Field,* 7"x5", Scratchboard, 2012, Patrick Humphreys

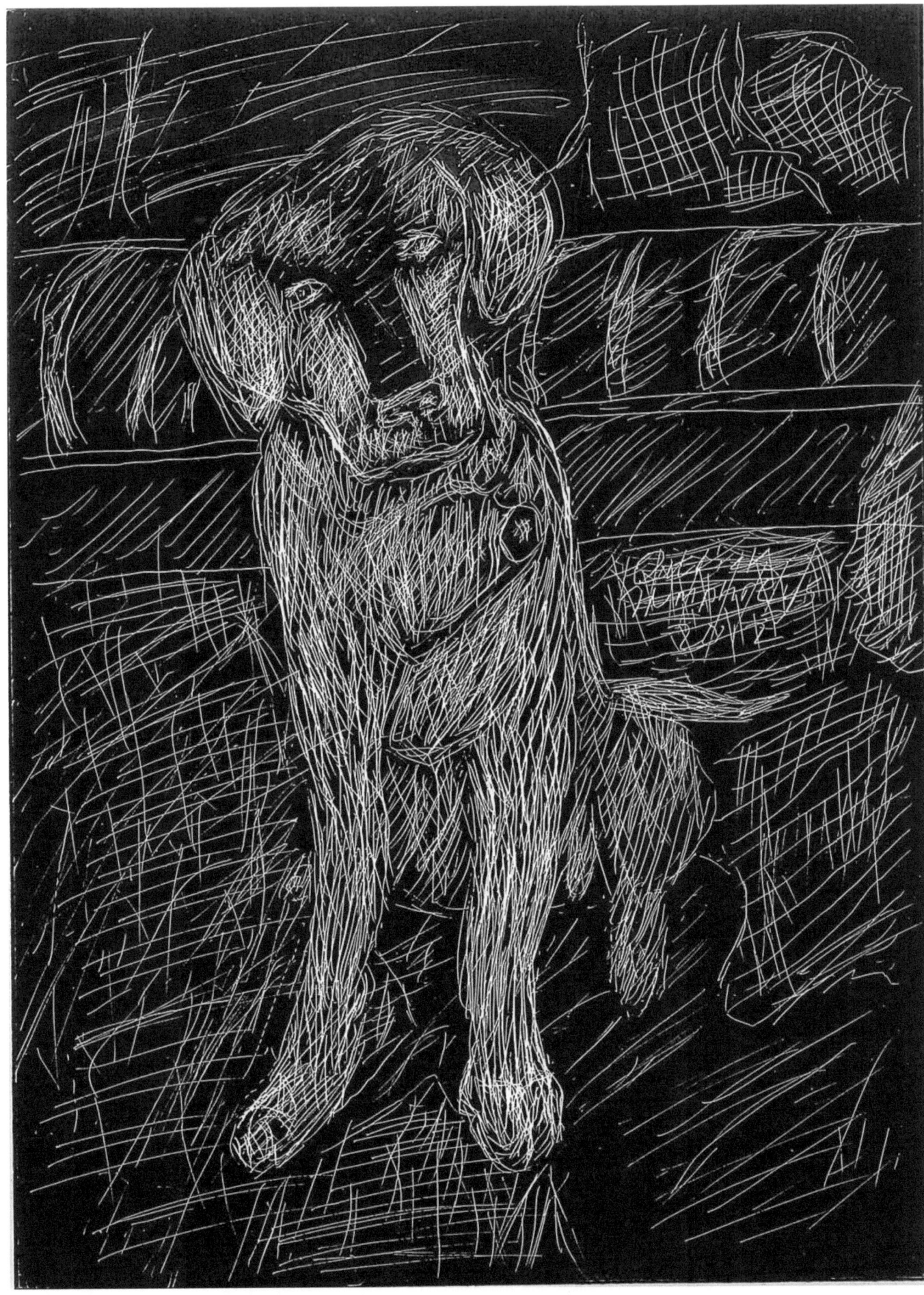

Figure 37: *Lab,* 5"x7", Scratchboard, 2012, Patrick Humphreys

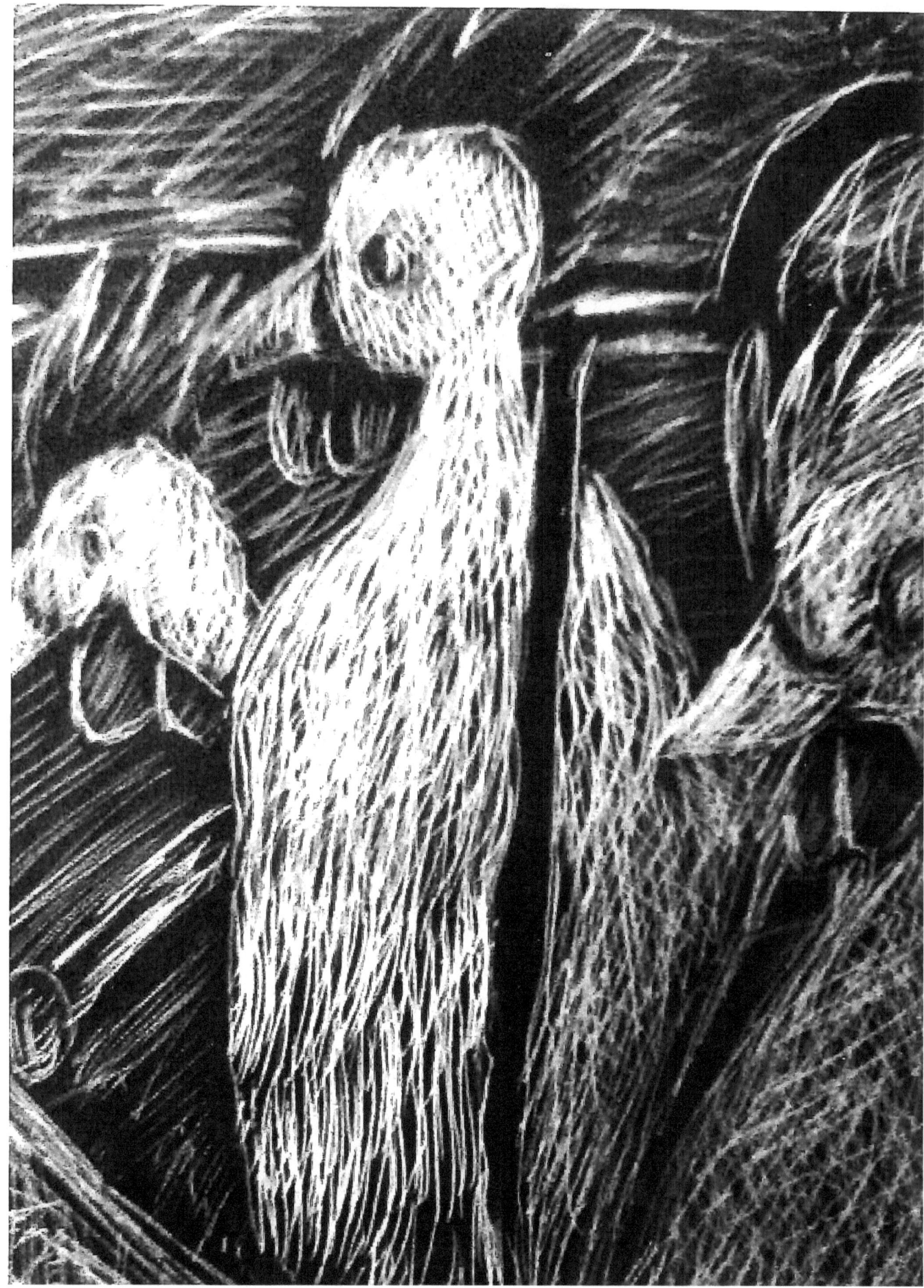

Figure 38: *Caged Emotions,* 5"x7", Scratchboard, 2012, Patrick Humphreys

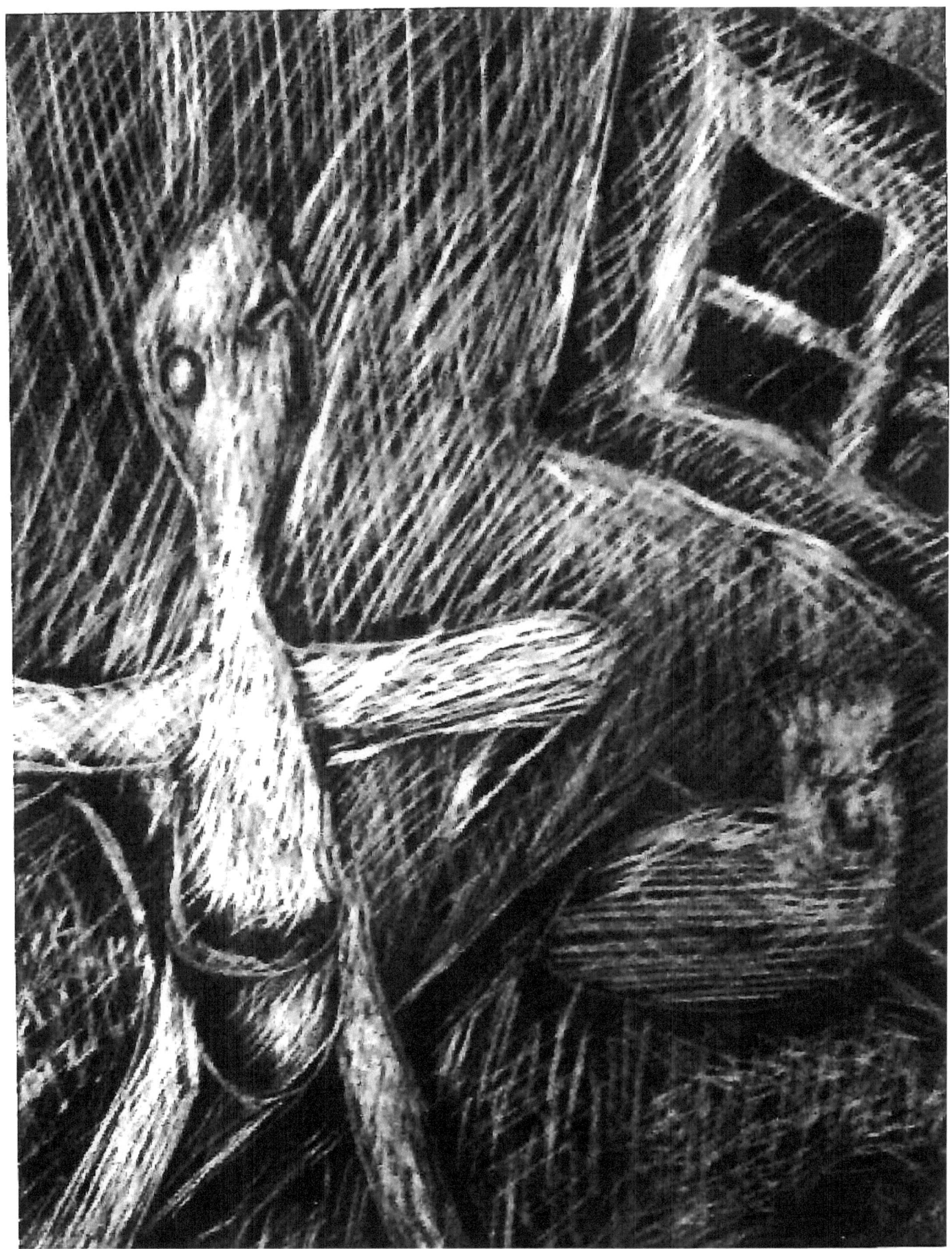

Figure 39: *Birds in Corner,* 5"x7", Scratchboard, 2012, Patrick Humphreys

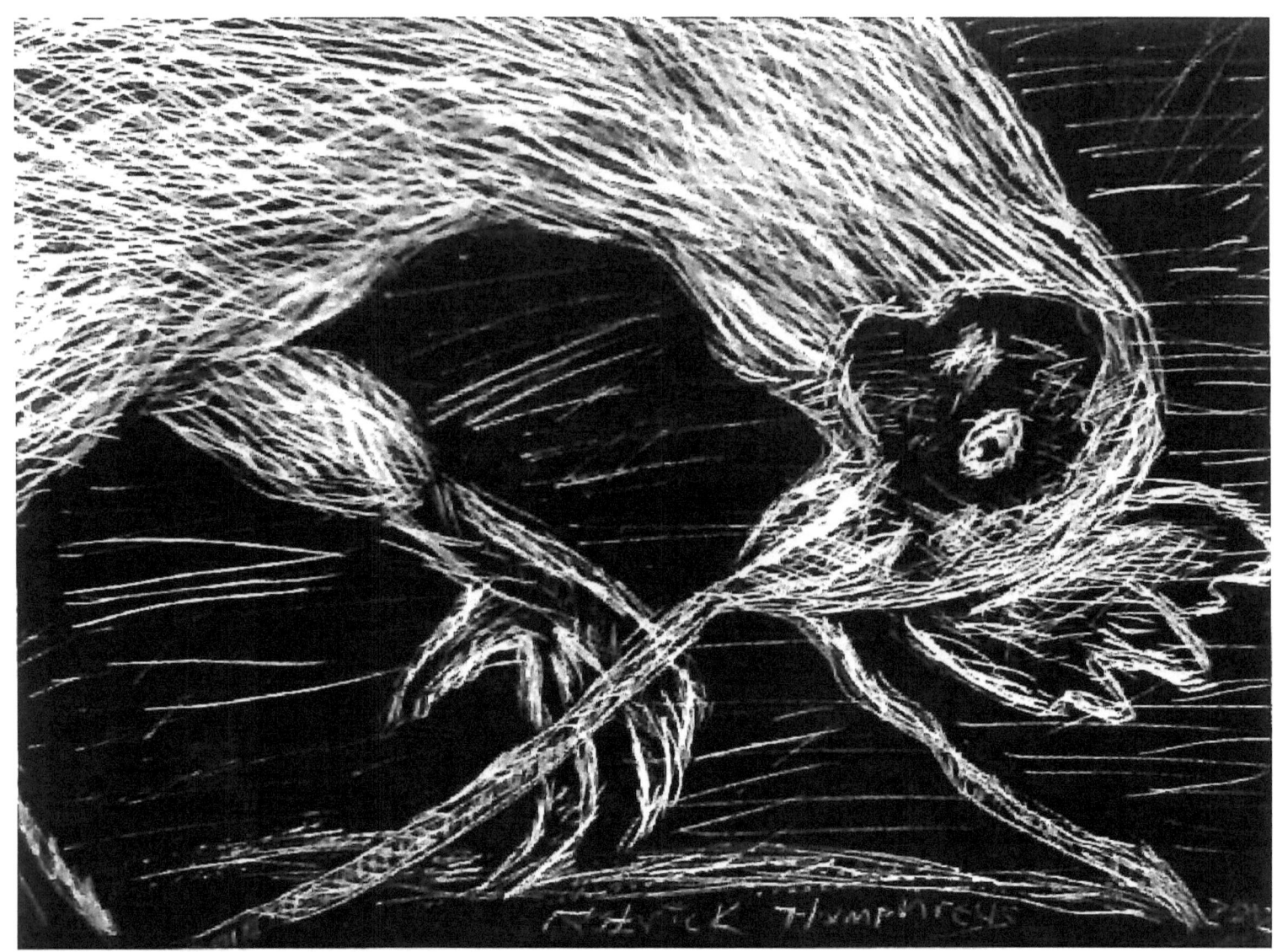

Figure 40: *Chicken with string.* 7"x5", Scratchboard, 2012, Patrick Humphreys

CHAPTER 5: SCRATCHBOARDS BASED ON PAINTINGS

This chapter contains scratchboards influenced by my paintings. As mentioned before I love to paint primarily with acrylic paint. This series of scratchboards are the value studies based upon the paintings. Sometimes the painting precedes the scratchboards sometimes the other way around. I learn from the paintings as much as the scratchboards. They go hand in hand with each other. Not totally different media working against each other but benefiting from the unique nature of each media.

Figure 41, *Cameron looking at Youthful Playthings, Version 1* is a good example of this. This scratchboard is based on one of my paintings, entitled *Cameron looking at Youthful Playthings.* The youthful playthings are toys in this particular image they are Japanese toys: Booska and Baby Godzilla. I like this image so much I did another version. This scratchboard, Figure 42, *Cameron looking at Youthful Playthings Version 2* is a larger scratchboard than the first version. More detail can be seen in this version.

The next scratchboard, Figure 43, *Girl Looking at Peacock*. I have introduced this image before. It is the completion of Figure 3. Figure 3 showed the beginning stages of the completed scratchboard (fig 43). This image is based on one of my paintings done in grad school. The subject matter is of a girl sitting in a chair with a peacock walking toward her. This scene I witnessed while visiting the Binder Park Zoo in Battle Creek, MI. A painting then much later a scratchboard based on a photograph.

Figure 44, *What Are You Looking At* is based on a painting done with a still life of my toys arranged in a manner that suggests a crucifixion. It wasn't my intention to evoke a crucifixion but I did so unconsciously. This is also a conscious tribute to one of my favorite artists, Francis Bacon, who employed the crucifixion composition in many of his paintings.

The following scratchboard, Figure 45, *Tribute to Gon'l*. Not many people have heard of the artist Gon'l. He is not a well known artist (someday he will be) but more importantly he is a well known friend. He is a local artist in the Bay City, MI area whose opinion and friendship I value. Gon'l isn't his real name, but his artistic persona. His real name is Richard Long, and he currently shows his works at the C.A.T Works gallery inside the historic Larson's Building in Bay City, MI. I currently show my work included in this book there as well as my paintings thanks to the owner of the gallery, Tom Larson, Whom I also consider and value as a friend and colleague. Tom Larson is also an artist. His work, Gon'l's and mine can be seen on the C.A.T. Works Gallery Facebook page. This scratchboard, Fig 45 is the only artwork I have ever dedicated to an artist and a friend!

Bird Foil, Figure 46 is another important image for me. This scratchboard is based on an important painting I did in grad school. The title, *Bird Foil*, is the title based upon the suggestion of one of my professors at WMU, Vince Torano. He explained to me that a foil is a breakthrough artistically. For me, this was a breakthrough from the more realistic to the more abstract. The subject matter are chickens, but not naturalistic ones. Through the inclusion of human teeth and lips, I have given the chicken "teeth" to fight back, to escape from their cage.

The last image in this chapter, Figure 47, is another important image but it is important for another reason. It is based on a painting that showcases my most prized thing, my son Cameron. This scratchboard illustrated Cameron and his cousin Keegan in the bathtub. Cameron is the smaller Figure, the calmer one, with his cousin, Keegan, the defiant one, whose raised arm shows his disgust with being in the bathtub. Cameron on the other hand is calm and content in the water. He is a great son. I love him so much!

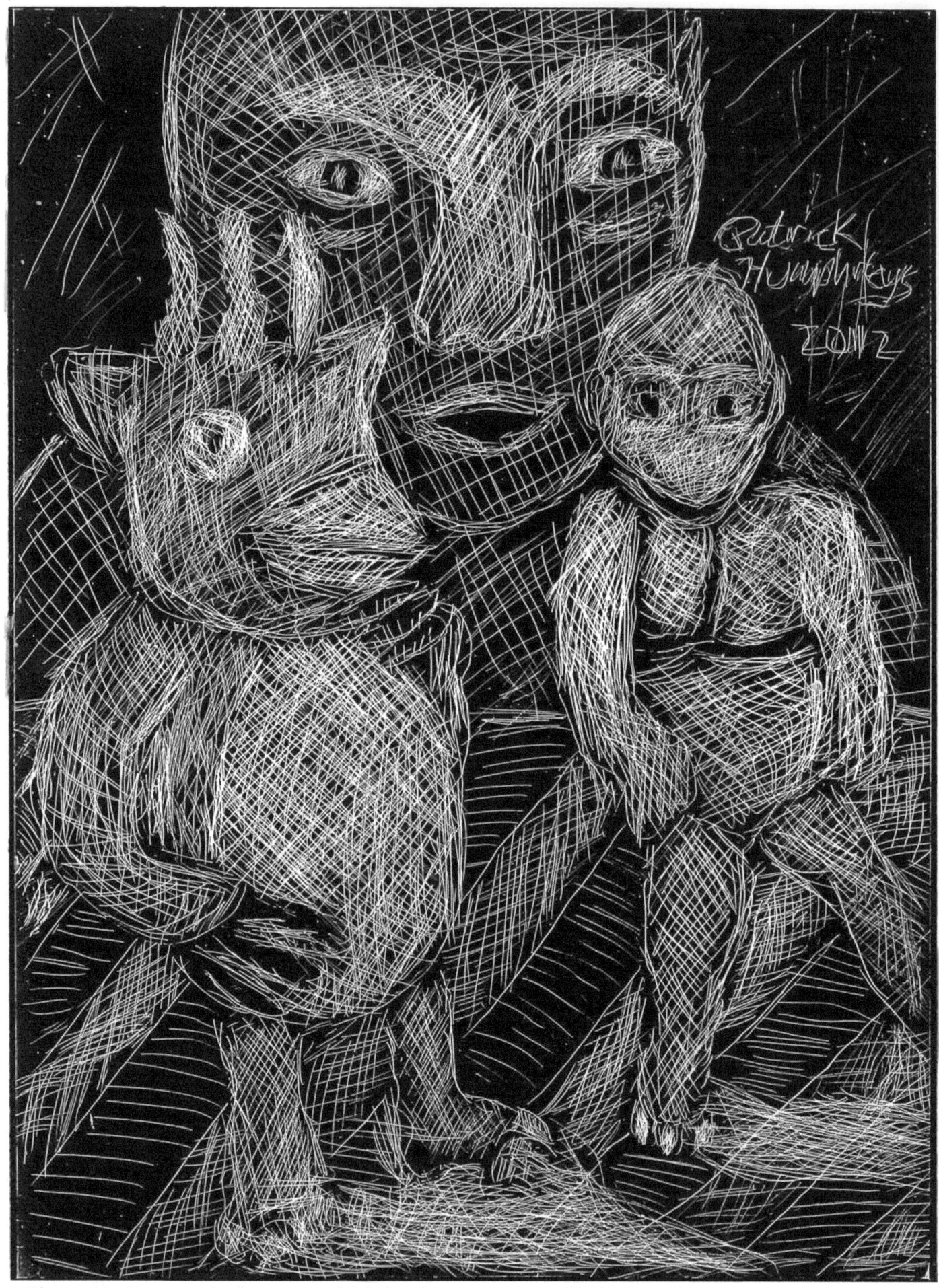

Figure 41: *Cameron looking at youthful playthings version 1*, 5"x7", Scratchboard, 2012, Patrick Humphreys

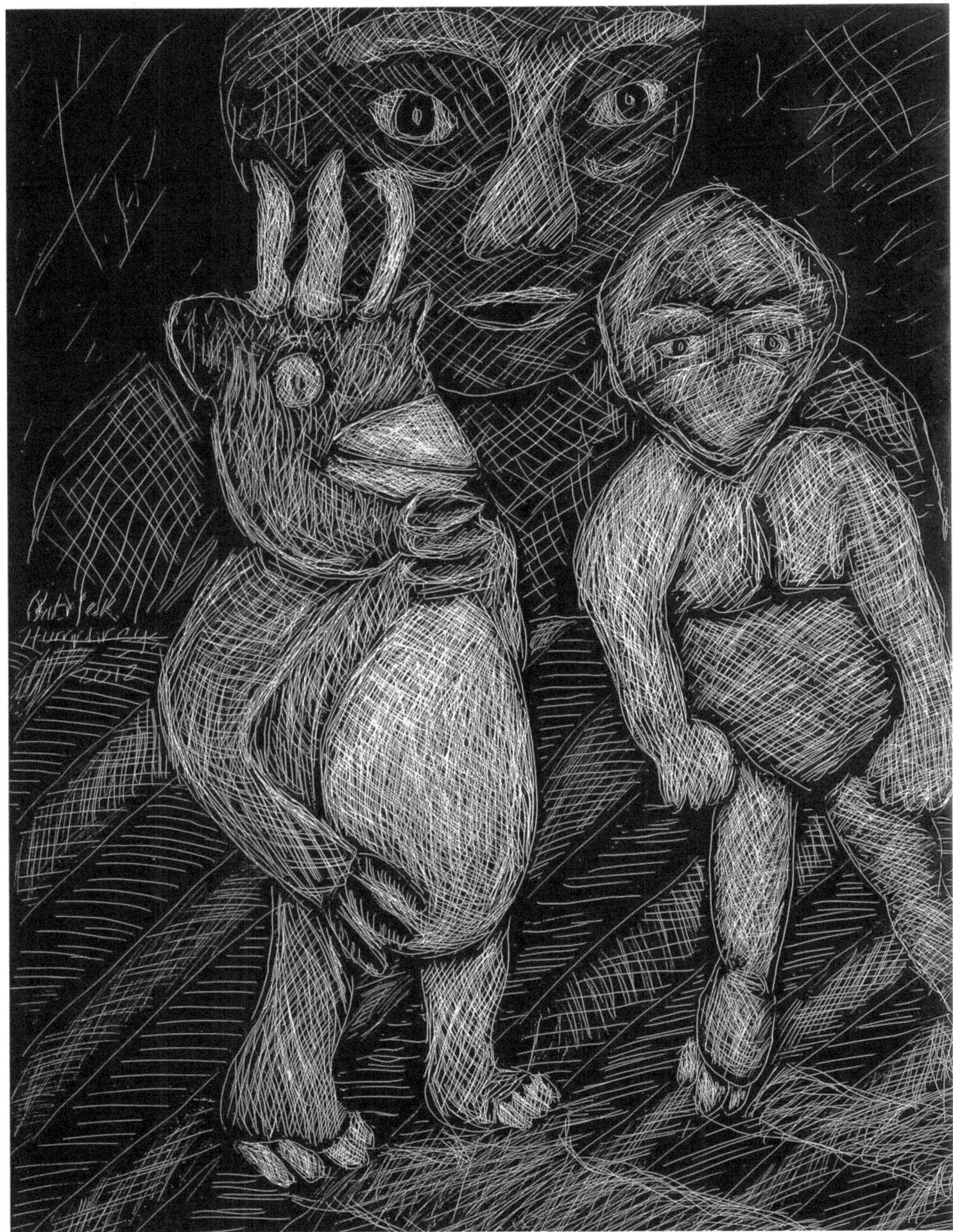

Figure 42: *Cameron looking at youthful playthings version 2,* 8"x10", Scratchboard, 2012, Patrick Humphreys

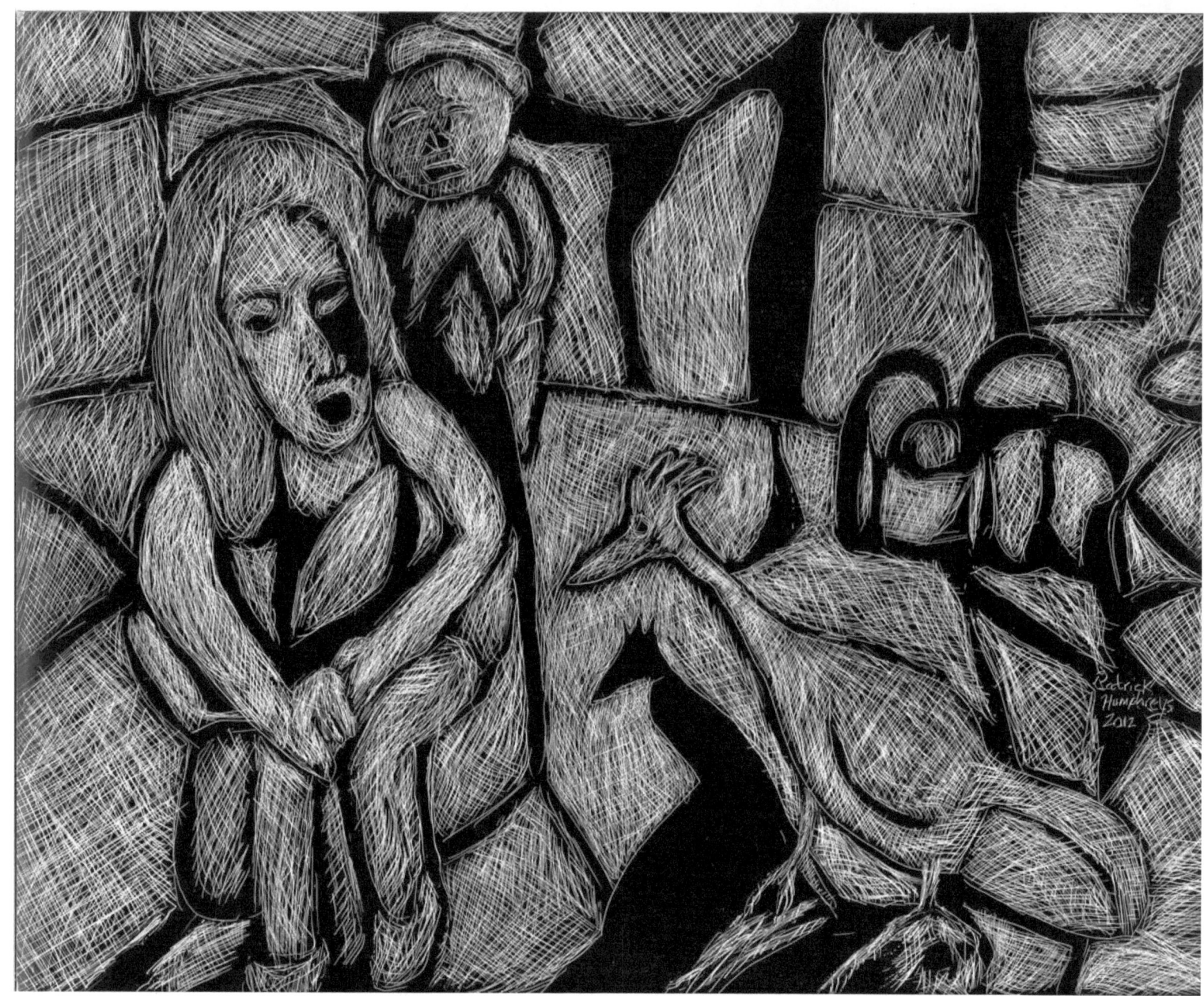

Figure 43: *Girl looking at peacock*, 14"x11", Scratchboard, 2012, Patrick Humphreys

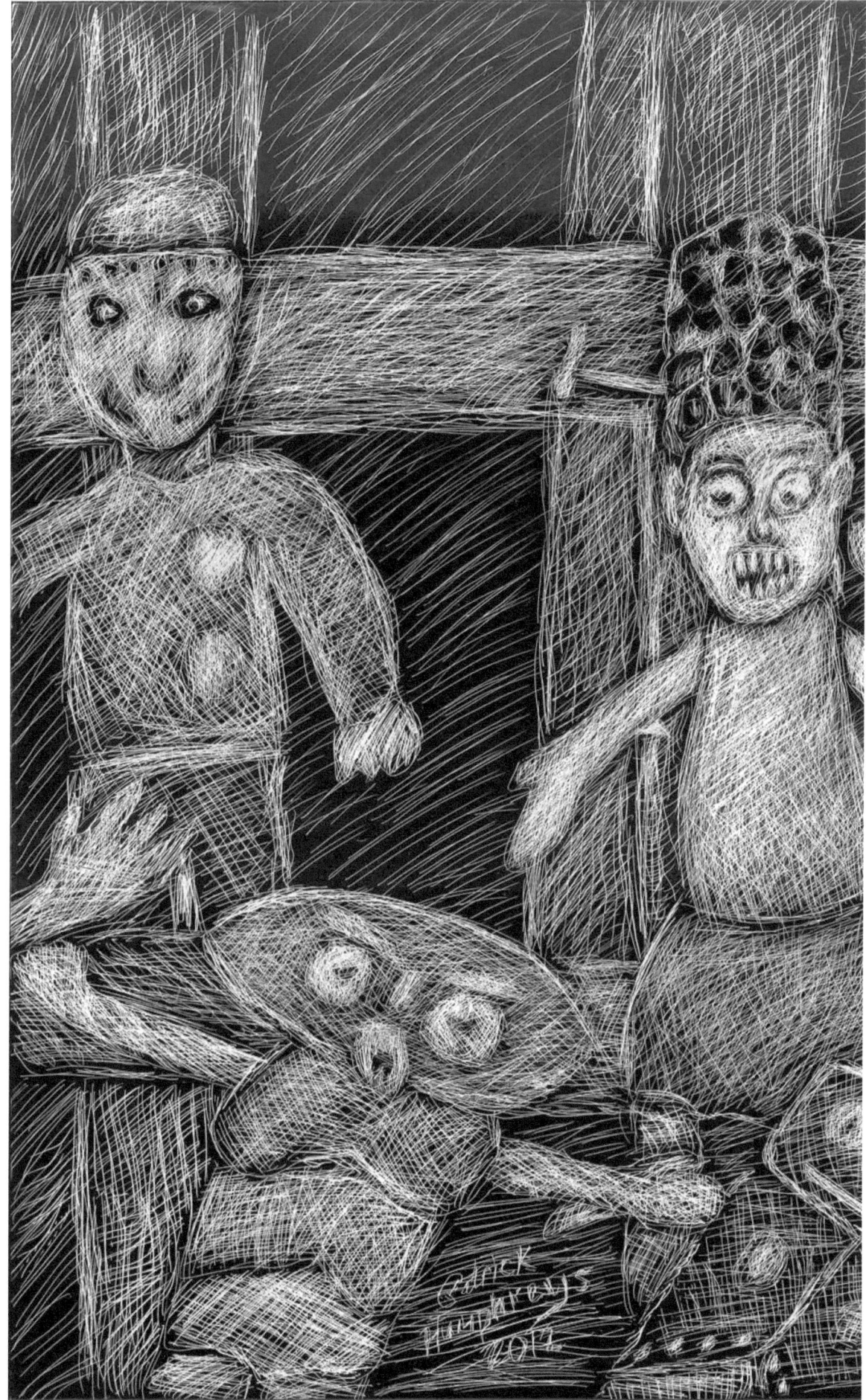

Figure 44: *What are you looking at?* 9"x12", Scratchboard, 2012, Patrick Humphreys

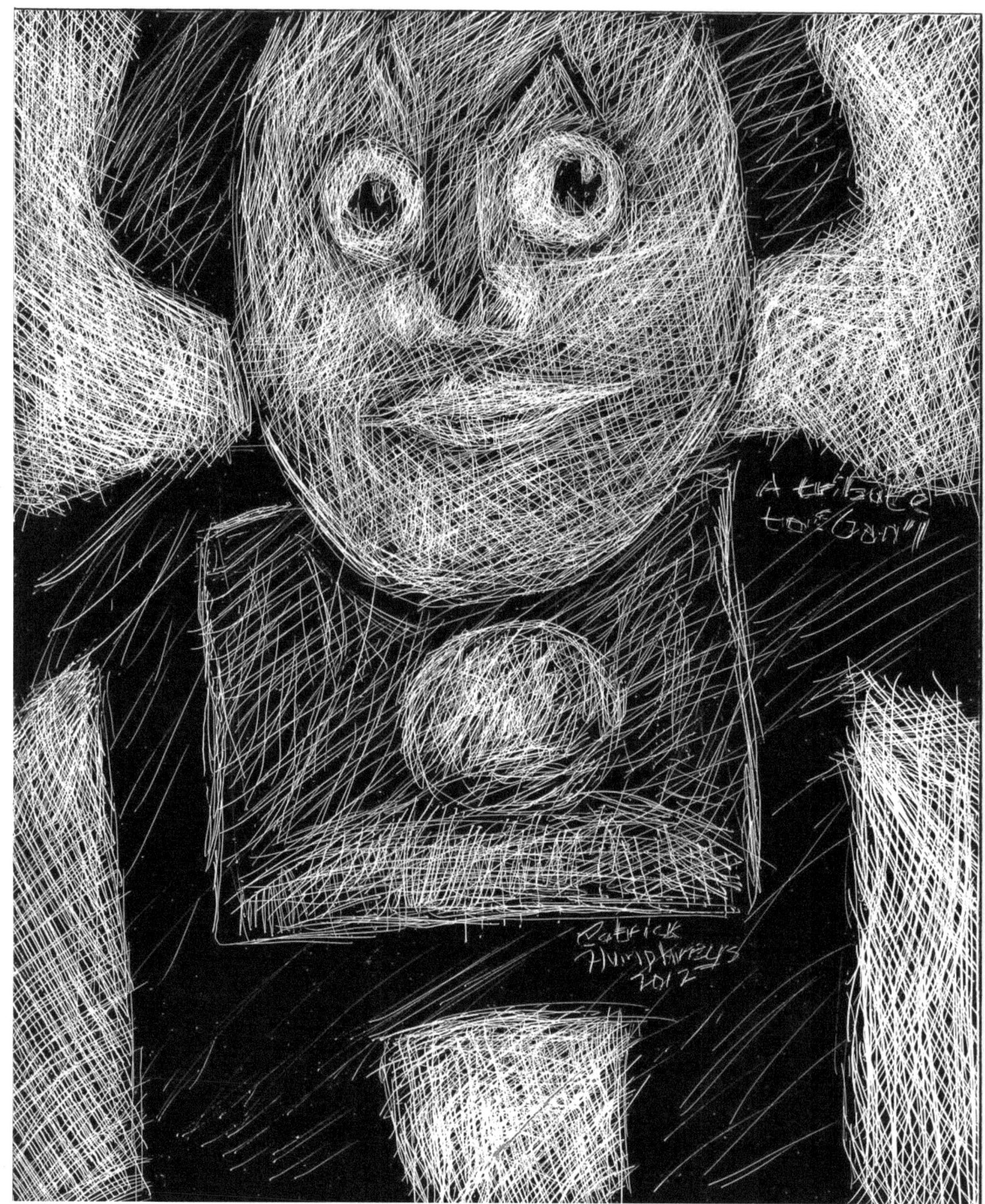

Figure 45: *Tribute to Gon'l*, 8"x10", Scratchboard, 2012, Patrick Humphreys

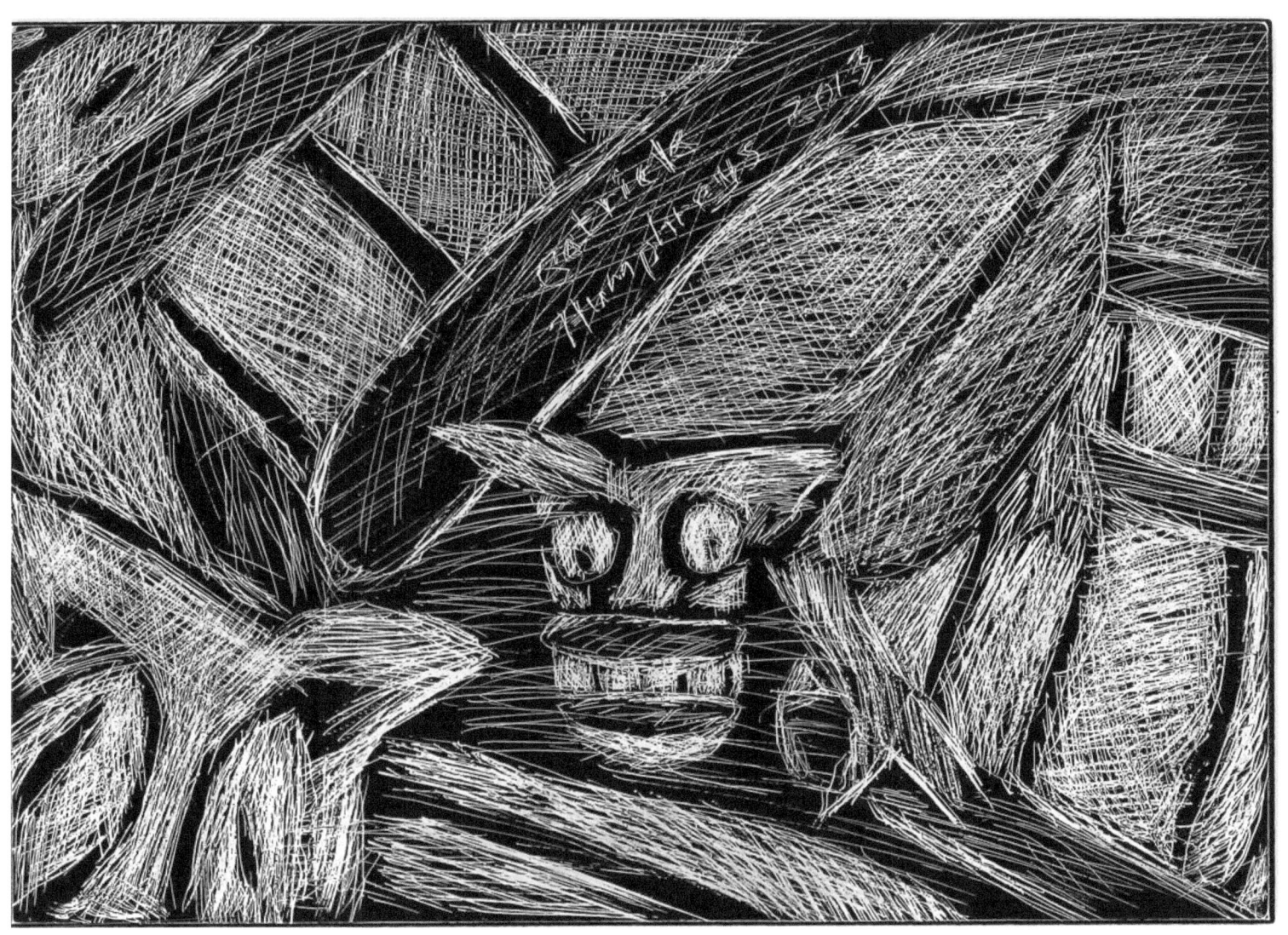

Figure 46: *Bird Foil,* 7"x5", Scratchboard, 2012, Patrick Humphreys

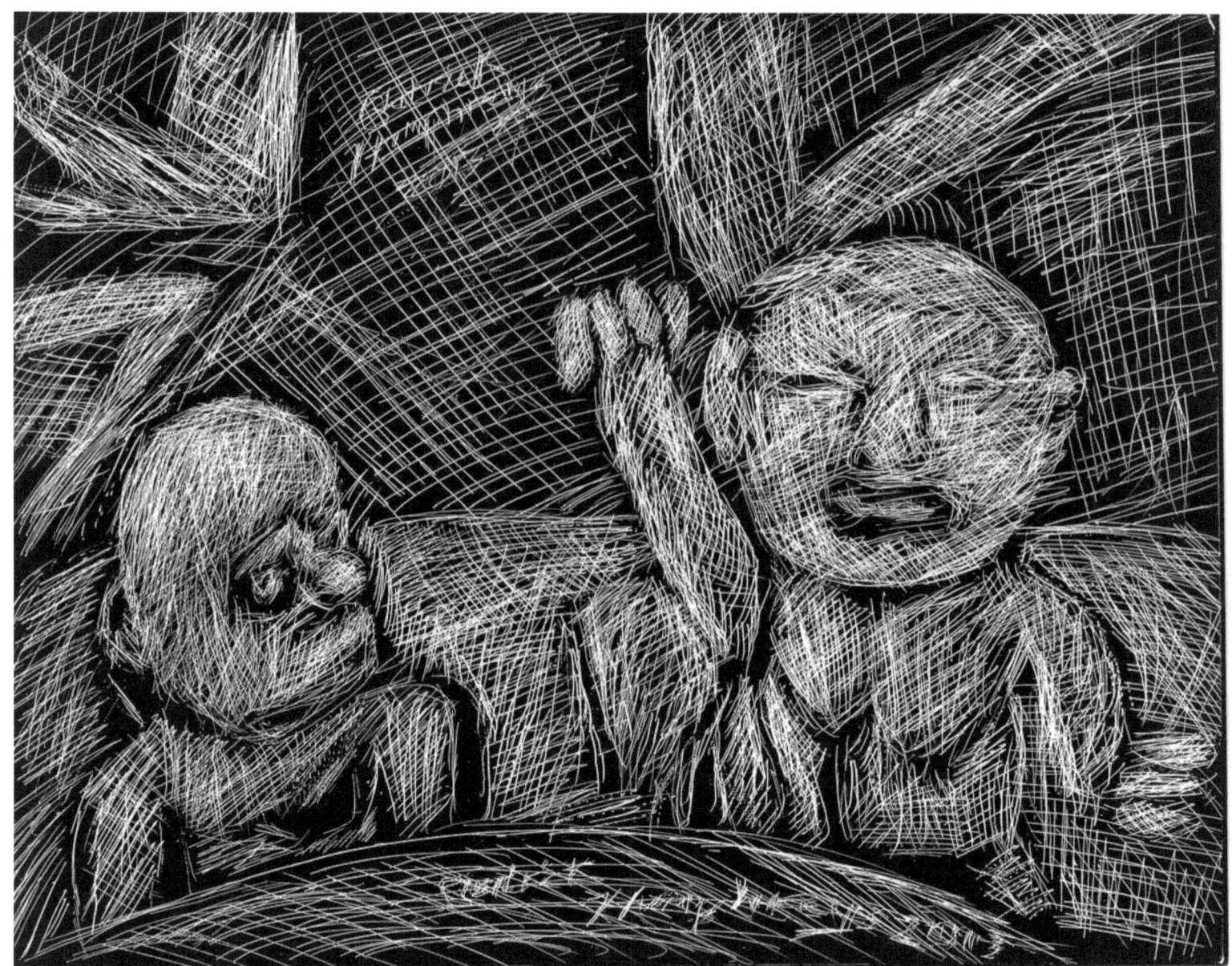

Figure 47: *Cameron and Keegan in bathtub,* 7"x5", Scratchboard, 2012, Patrick Humphreys

CHAPTER 6: WHATEVER

This chapter I entitled Whatever. Why call it Whatever? It was my son, Cameron's idea. I have several sketchbooks I am currently working on and I had a problem naming them and Cameron suggested that I call them my Whatever books What a great idea!

Whatever works well for this chapter as well. It is at first glance a series of images that are unrelated but are they really? You be the judge, but they are grouped together for a reason!

Figure 48, _NO!_ harkens back to my love of cartoons. This image is of a group of unhappy flowers. Why are they unhappy, we don't know, but it is Whatever!

Christmas is the theme of the next three scratchboards. Figures 49, 50, and 51 clearly illustrate this fact. A toy snowman figure is used in all three examples. These three images could be included in chapter 3, but are they? No. They are included in this chapter because in my mind they belong here! For what reason? Whatever! Whatever I want!

The last five images are my strongest ones in my mind. They are visual memories of a painful experience I lived through. What painful experience? WHATEVER could be that painful? A divorce. I was married for 13 years, always believing marriage would last forever, but for me it didn't.

Figure 52, _Big Loser, 25% Genius_, is a prime example of this sentiment. This image I combine with words to create a sum greater than both. The main image of this scratchboard is recognizable but what makes this image successful is the inclusion of the words BIG LOSER and upon closer inspection other words as well: USE YOUR BRAIN!, WHY? and looking at the image longer you can make out other words and phrases.

Figure 53, further this sentiment. In my divorce hearing, my wife at the time tried to use my artwork to not let me be able to see my son. I was at the time working on a series of images pertaining to dissections. SHE BROUGHT IN IMAGES TO THE MAGISTRATE TO USE THEM AGAINST ME! TO ILLUSTRATE THAT I'M A BAD INFLUENCE FOR MY SON BY EXPOSING HIM TO SUCH IMAGES! WHATEVER! He will learn about dissection in school!

The main figure in this image is a dissected rabbit. What makes this image richer is the inclusion of words. Arranged around the dissected rabbit you can make out: "Will I ever find love again? Why? Alone all the time? 100% Idiot!" the rest I will leave up to you to read from this image

The next image, Figure 54, is another powerful image for me. The main image again is of a dissected animal, in this case a bird. What is written around the bird is something bad she called me on several occasions, very bad things indeed. "I see a f***in' idiot! Use your brain! '98-'12." Very powerful words, but could an idiot create al these works in this book? No! WHATEVER!

The next image also illustrates a bad time in my life. Not only while going through a divorce, I also went through bankruptcy! The main image in this scratchboard, Figure 55, is of a toy robot. My love of toys and the desire to obtain as many as possible directly led to my flight into bankruptcy! I could not find love with her, so I bought my love (toys) instead.

The last image, Figure 56, which I entitled _THE END_ is the end image. This scratchboard also contains toys, 3 toys. These toys are viewed from the back. Are they running away or looking to the future? I believe they are looking to the future. The figure on the right has a good/evil switch. Was it good to create these last scratchboards that contain "evil" words? For me it was. Hopefully you can understand why these images helped me through a difficult time in life in order to look ahead and not back! It can only get better! Thanks for looking!

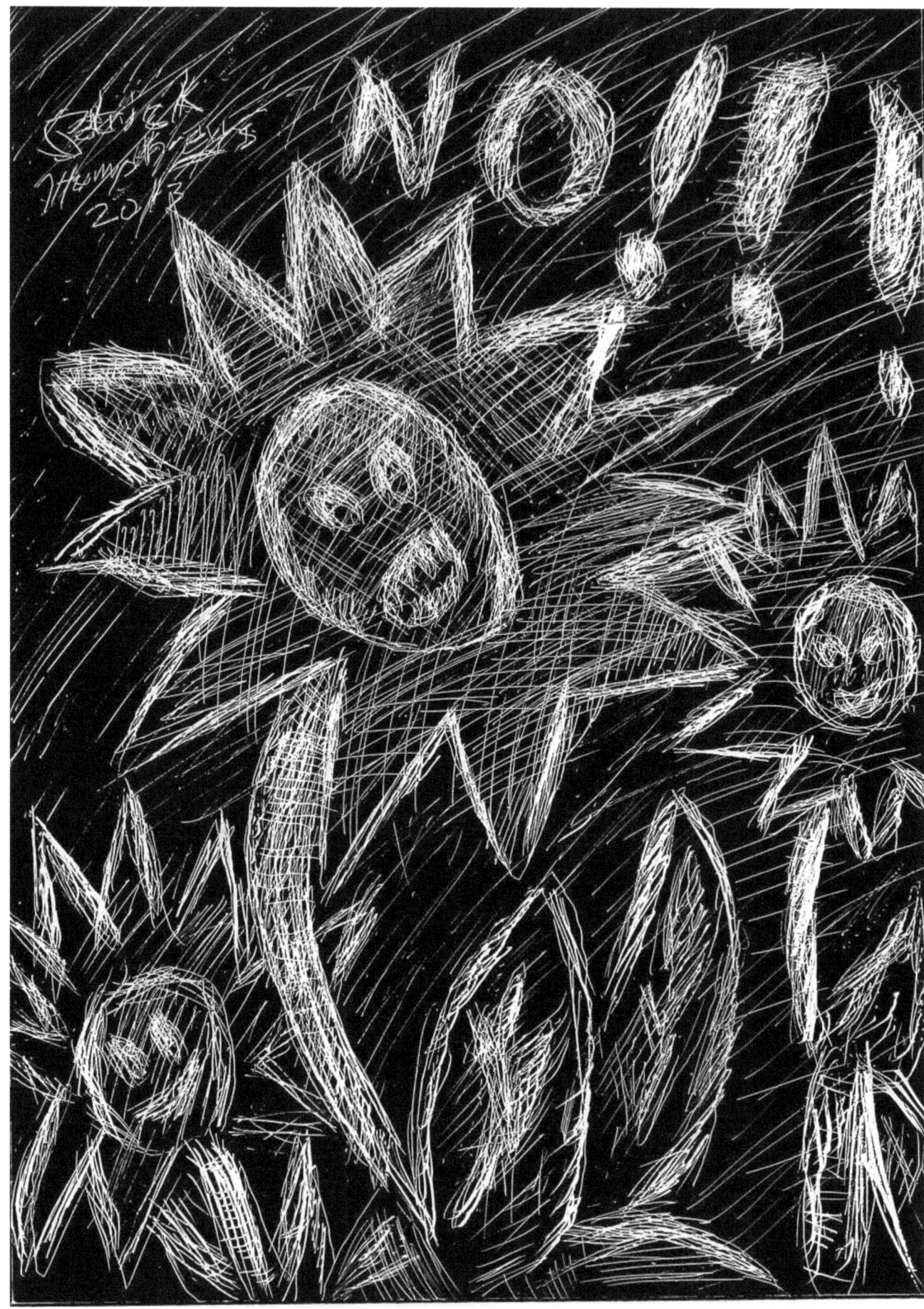

Figure 48: *NO! NO! NO!,* 5"x7", Scratchboard, 2012, Patrick Humphreys

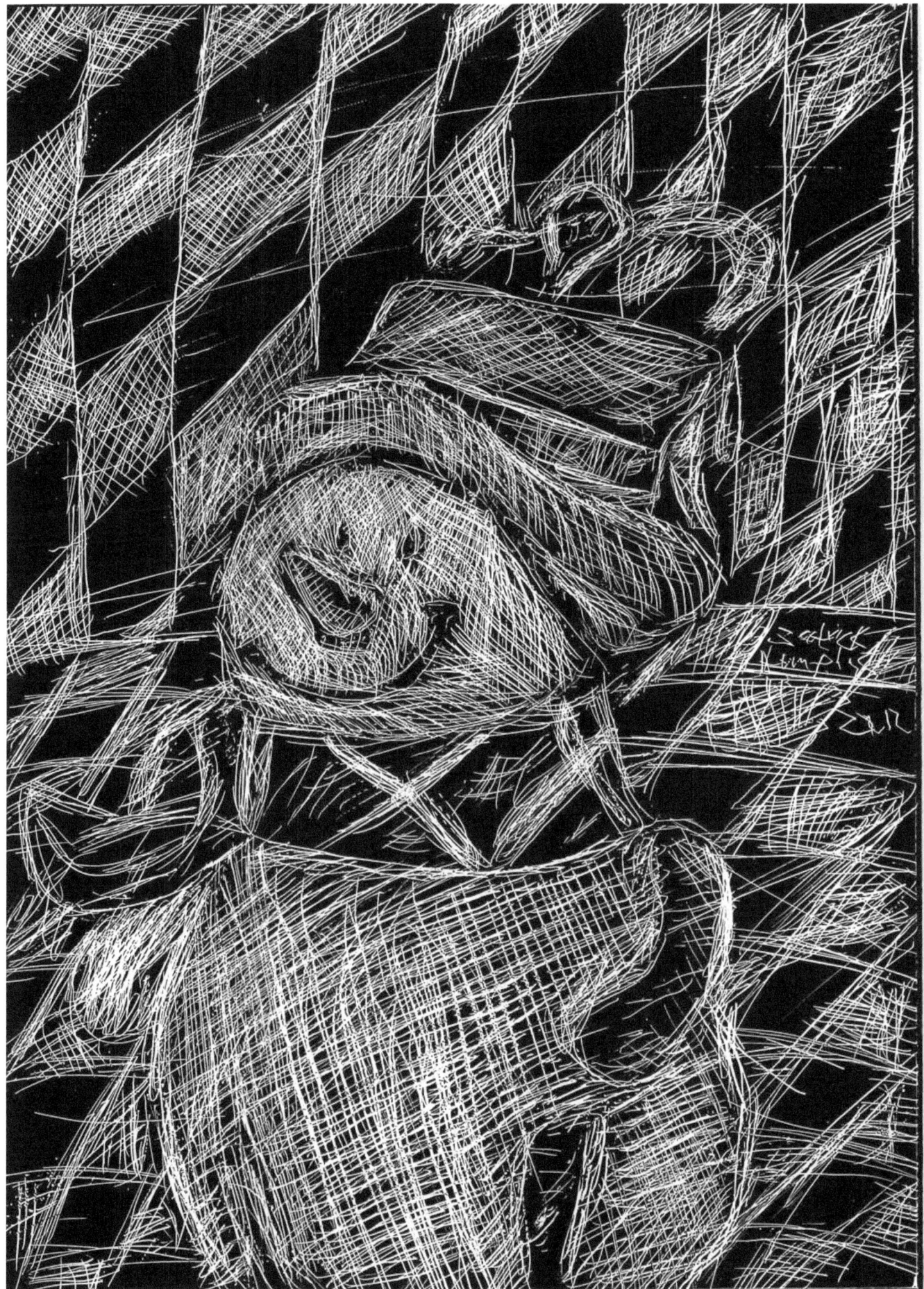

Figure 49: *Jinglebell Snowman,* 5"x7", Scratchboard, 2012, Patrick Humphreys

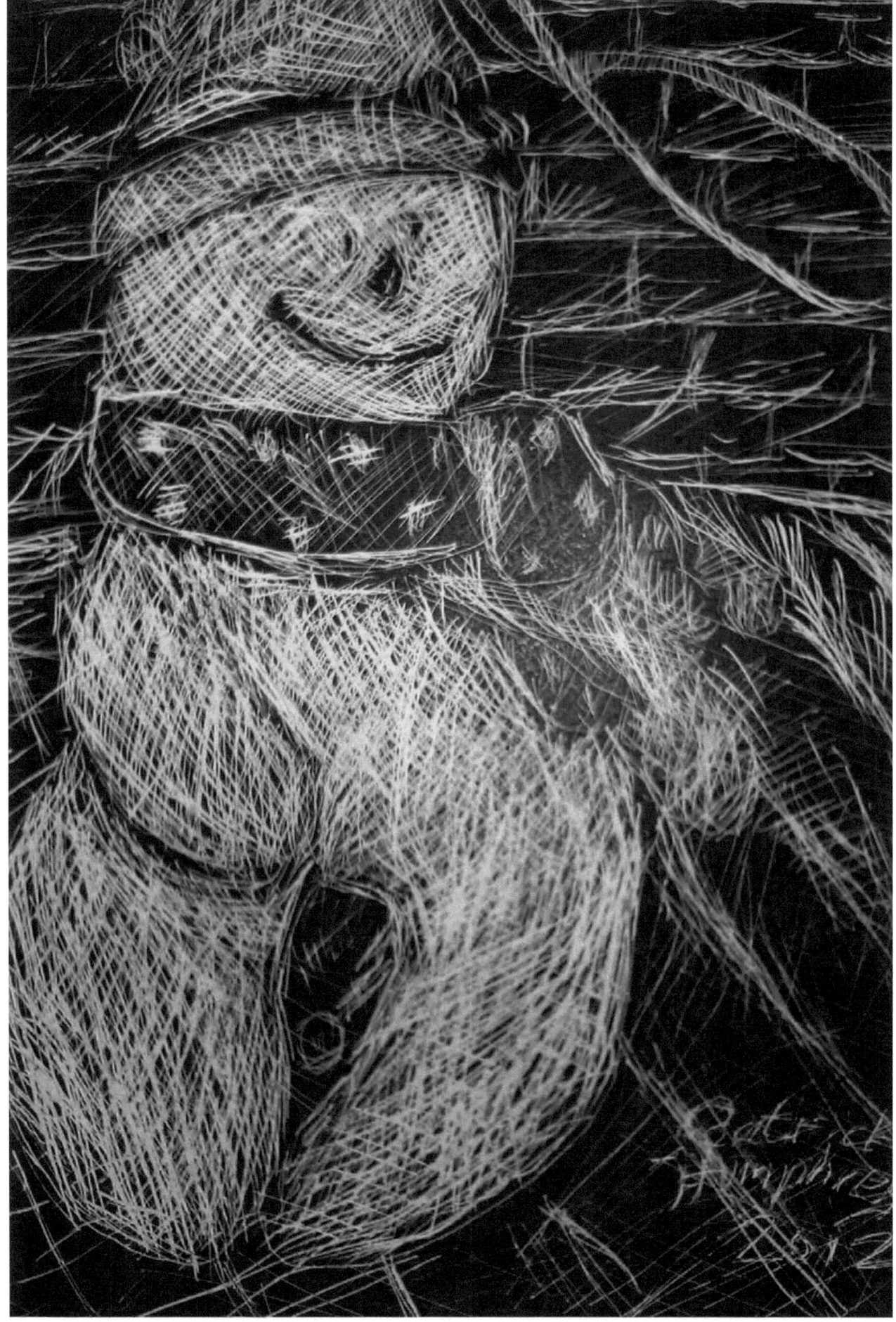

Figure 50: *Jinglebell Snowman version 2*, 5"x7", Scratchboard, 2012, Patrick Humphreys

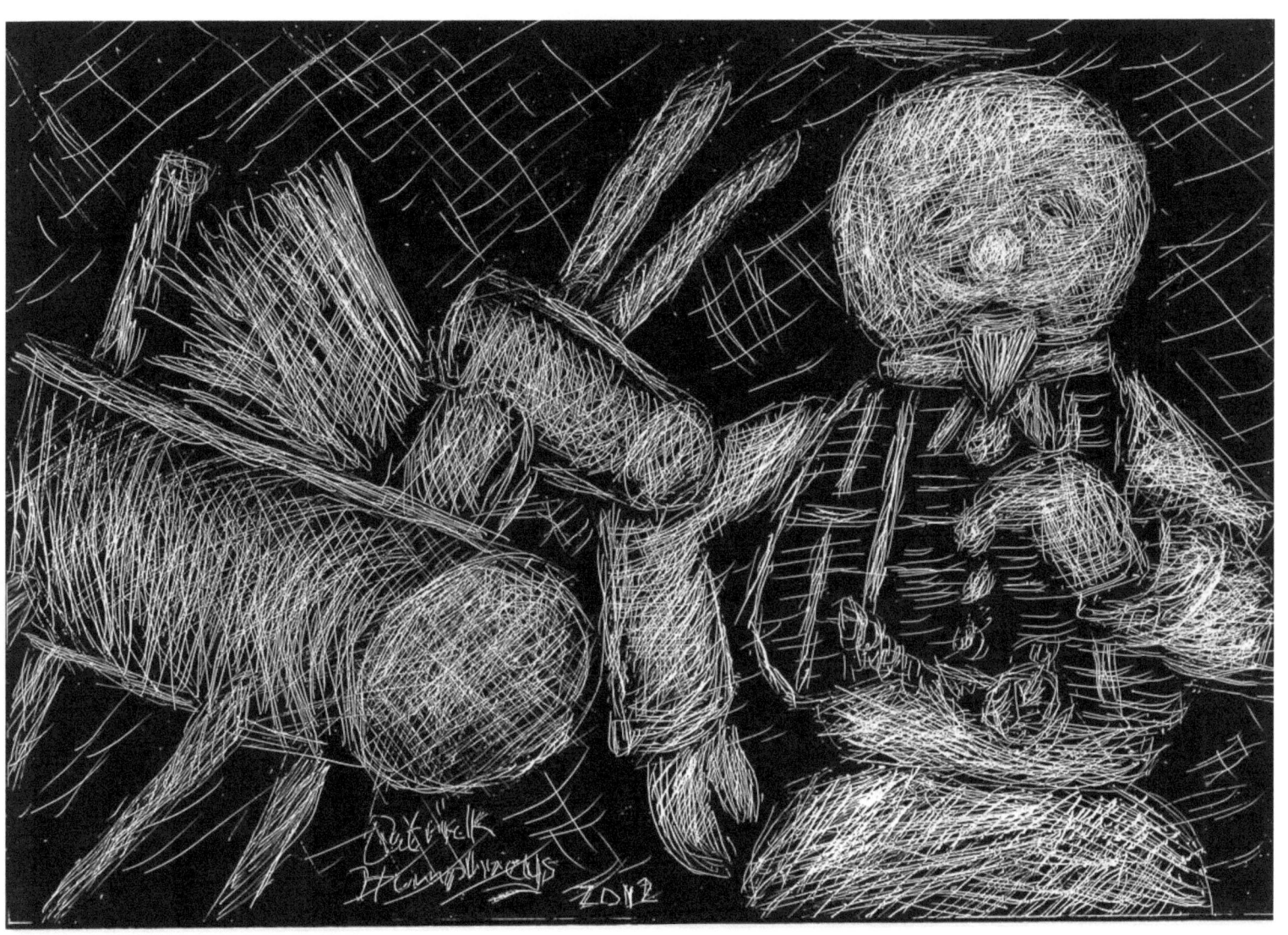

Figure 51: *Snowman with wooden reindeer,* 7"x5", Scratchboard, 2012, Patrick Humphreys

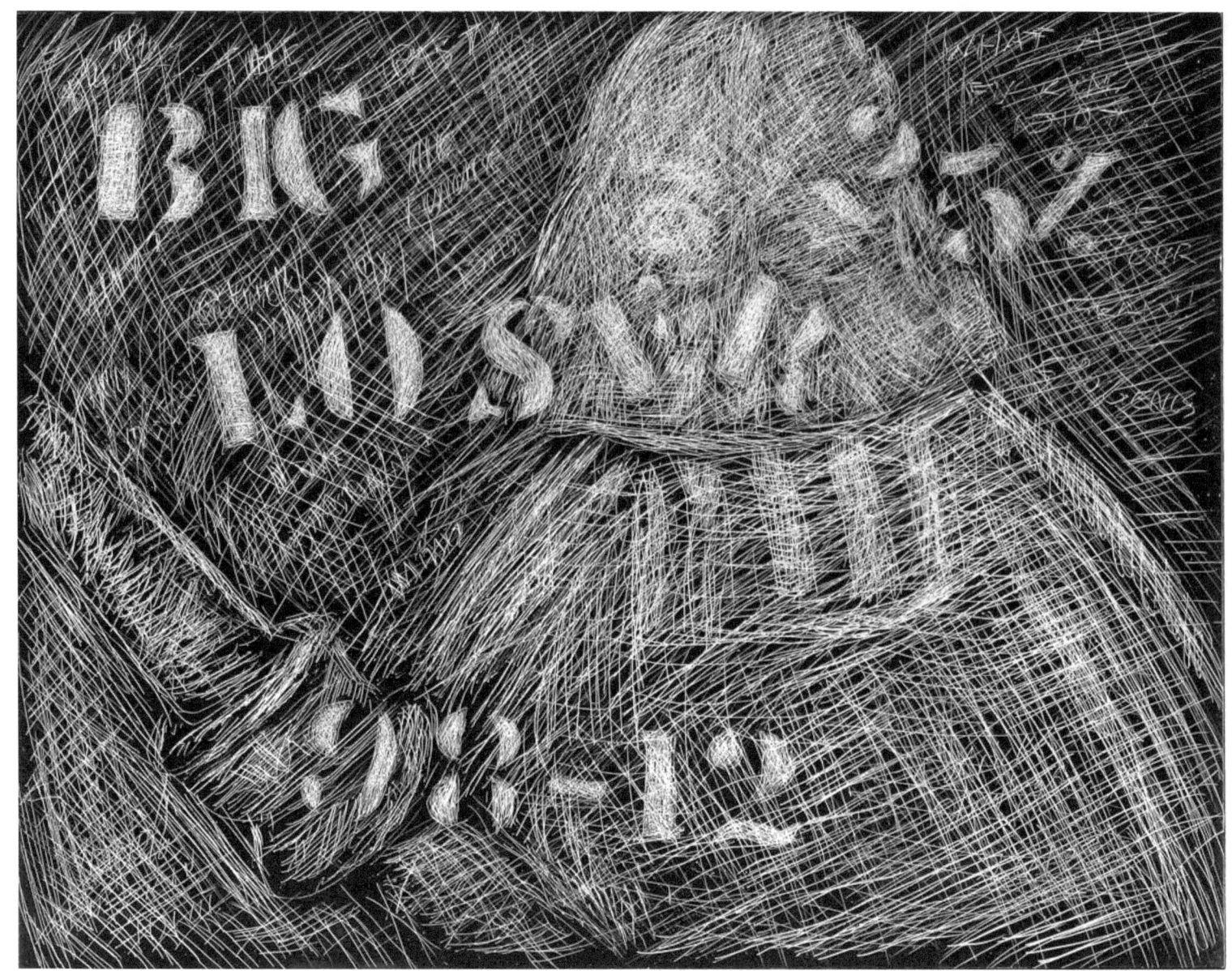

Figure 52: *Divorce Diary: BIG LOSER, 100%,* 10"x8", Scratchboard, 2012, Patrick Humphreys

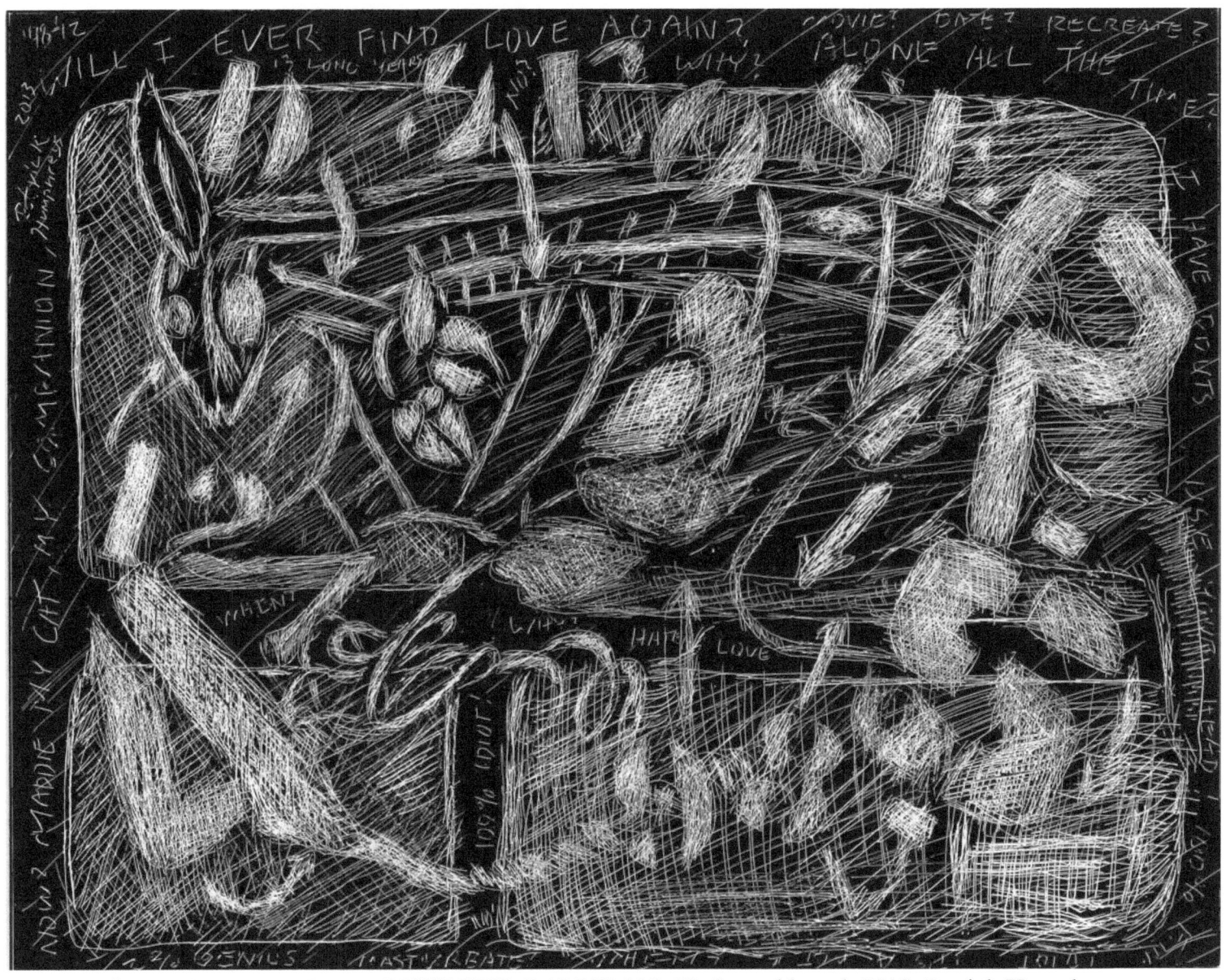

Figure 53: *Divorce Diary: DISSECTED RABBIT,* 10"x8", Scratchboard, 2013, Patrick Humphreys

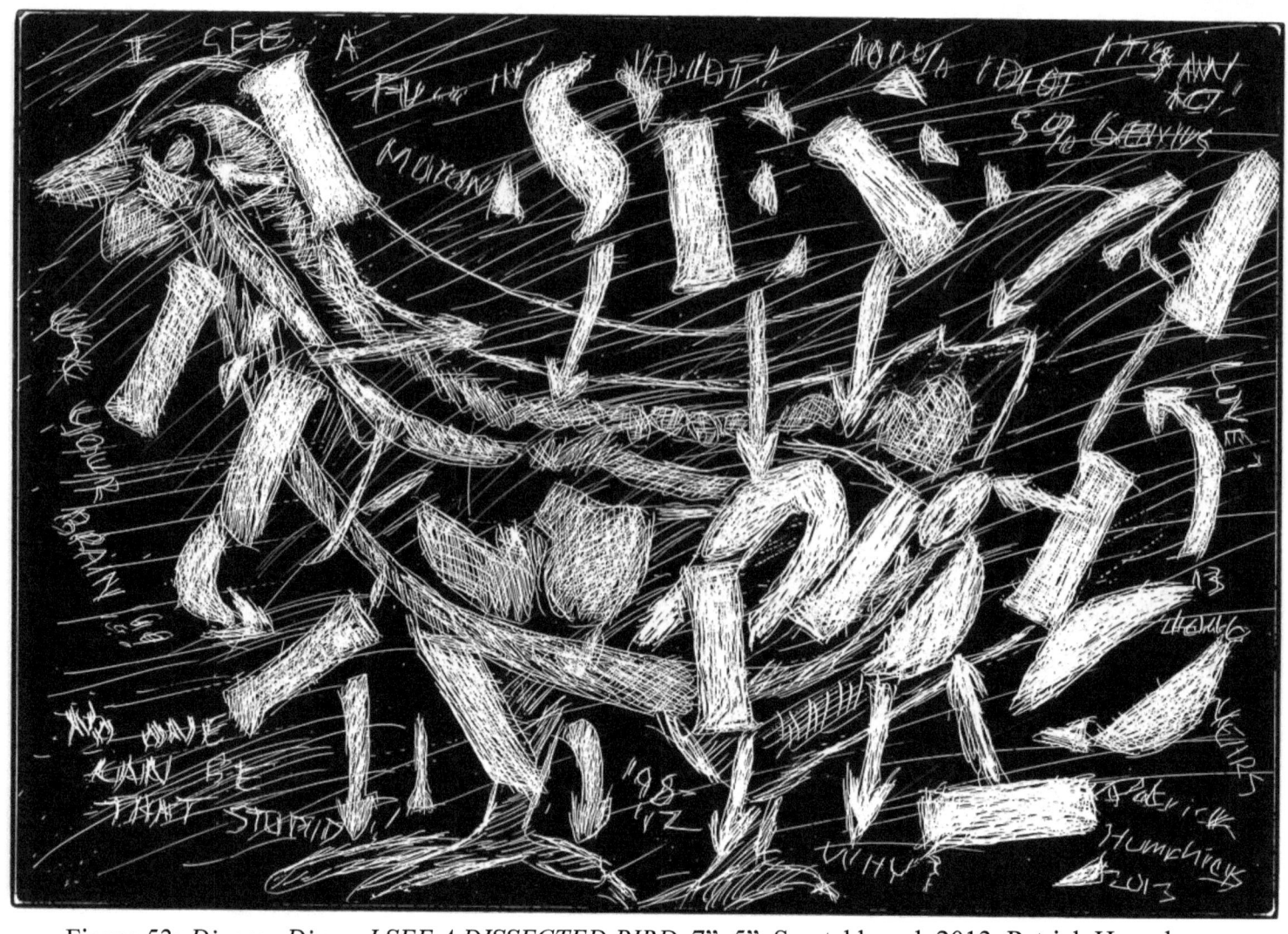

Figure 53: *Divorce Diary: I SEE A DISSECTED BIRD,* 7"x5", Scratchboard, 2013, Patrick Humphreys

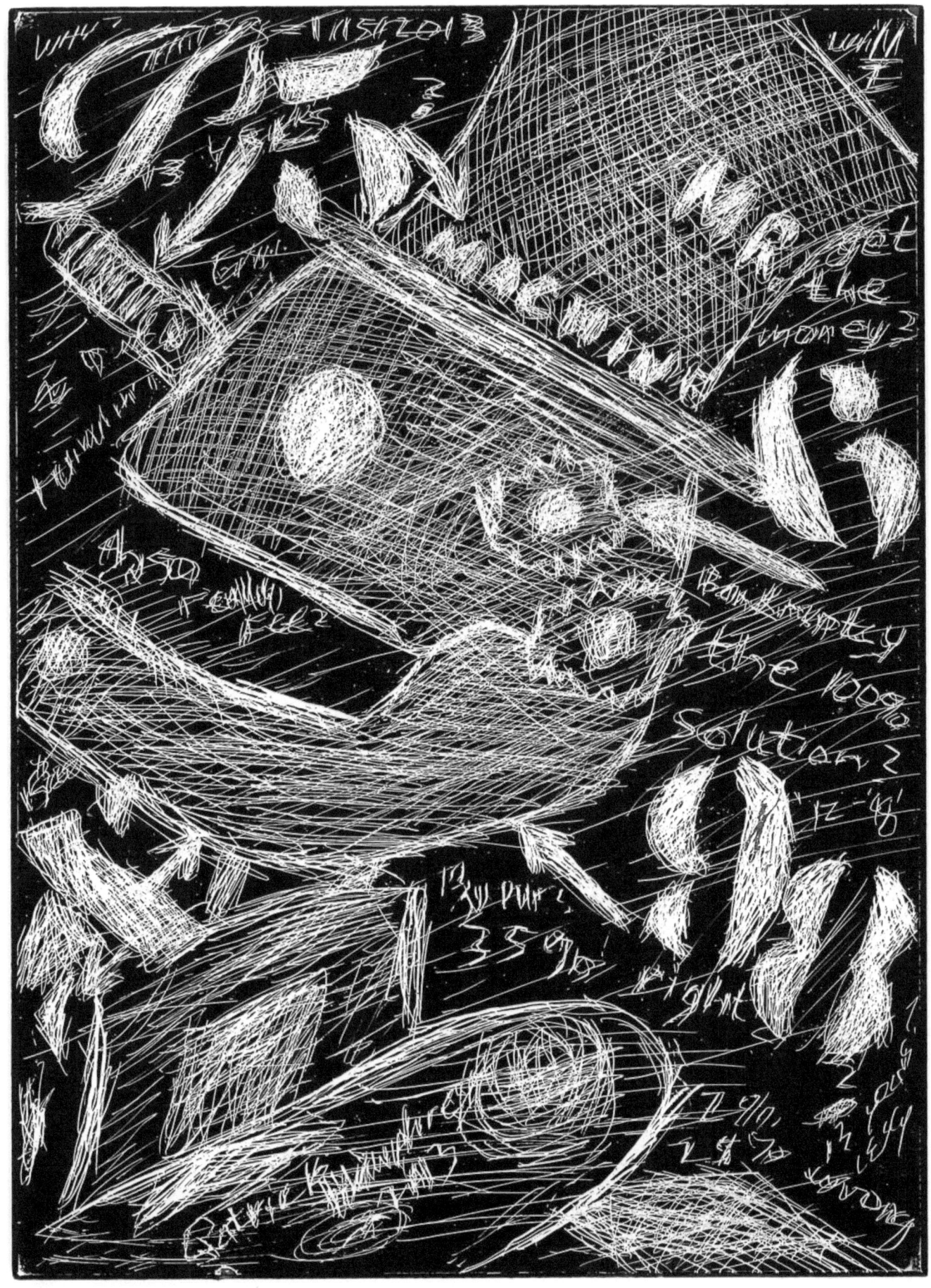

Figure 54: *Divorce Diary: BANKRUPTCY ROBOT,* 10"x8", Scratchboard, 2013, Patrick Humphreys

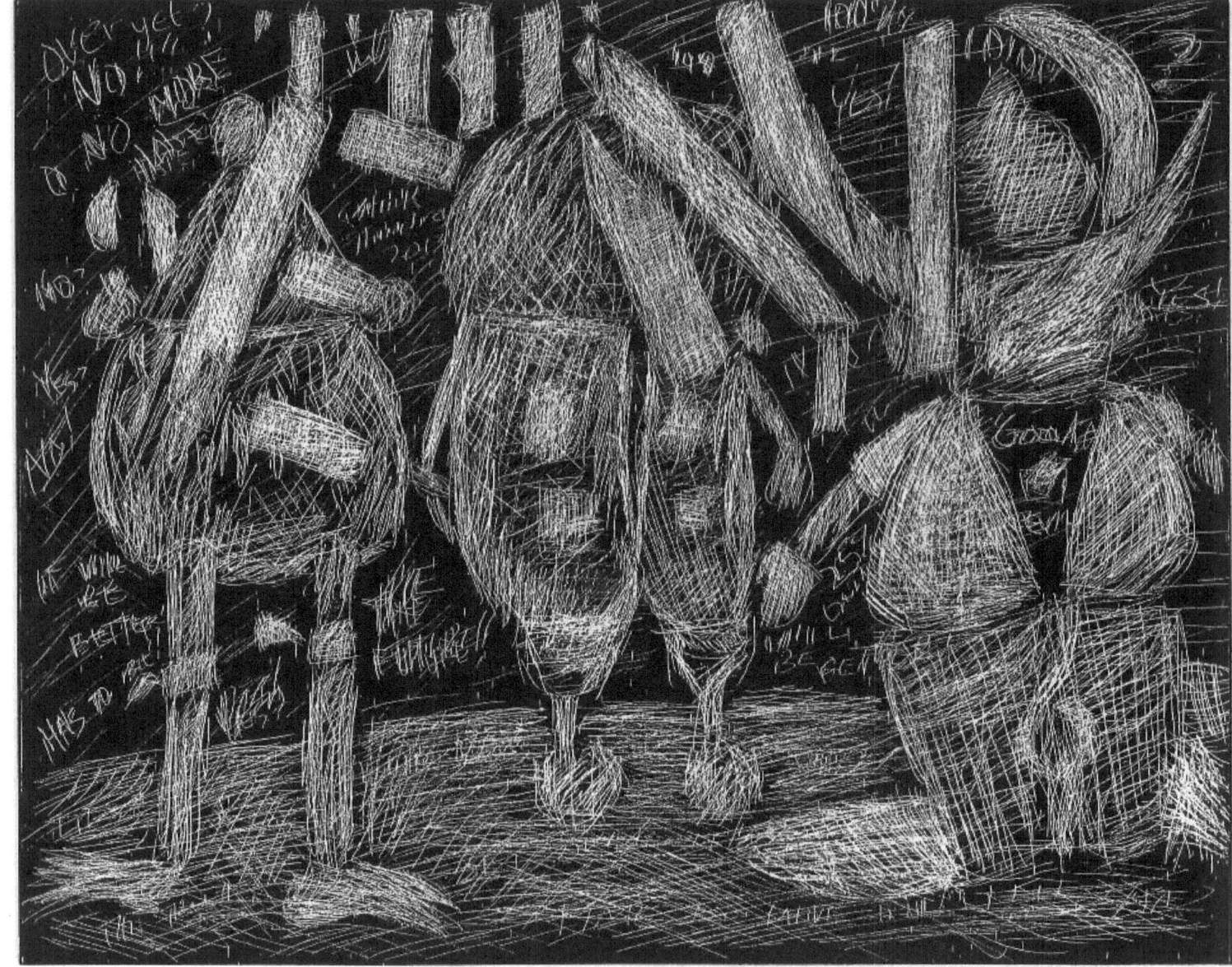

Figure 55: *Divorce Diary: THE END OR THE BEGINNING?*, 10"x8", Scratchboard, 2013, Patrick Humphreys

Thanks for looking!

Patrick B Humphreys
patcatart@gmail.com

CHAPTER 7: APPENDIX

This chapter is my thanking one, dedication one, etc.

FIRST OFF THIS BOOK IS DEDICATED TO MY SON, CAMERON

As of the writing of this book, this is the fourth book I have published.

Other books:

(1) 1,2,3 Kitties: A Cat Counting Book (paperback), PublishAmerica (July 7, 2008), ISBN-10:1606108042, ISBN-13: 978-1606108048

(2) Love of Tin Robots (paperback), PublishAmerica (August 4, 2011), ISBN-10: 1462633552, ISBN-13: 978-1462633555

(3) Low Key Supermarket Free Verse (paperback), PublishAmerica (July 14, 2011), ISBN-10: 1462629784, ISBN-13: 978-1462629787

My work can be seen online at www.fineartartamerica.com, search Patrick Humphreys

I participated in the Brooklyn Library Sketchbook Project. I am part of their digital library. Search under Patrick Humphreys or at www.sketchbookproject.com/library/6498

I also am on Facebook. Search for Patrick Humphreys, Bay City, Mi or https://www.facebook.com/patmfa2001 or also on Facebook at www.facebook.com/CatWorkArtGallery.com

My artwork can be seen locally at

(1) C.A.T. WORKS ART GALLERY, 514 Washington Ave, Bay City, MI 48708
 989.893.2771, ext. 6

(This gallery is inside the historic Larson Building)

(2) DoArt Art Gallery, 810 Washington Ave, Bay City, MI 48708
 989.391.9935, www.doallinc.org

I have also exhibited my work at the Saginaw Art Museum and the Creative Spirit Center in Midland, MI (now called 360 Degrees gallery.)

I received: MFA in painting from Western Michigan University, Kalamazoo, MI
 BFA in painting from Eastern Michigan University, Ypsilanti, MI

I would also like to give sincere thanks for all the help I received in putting together this book at the Bay Arenac ISD Printing Services, (4228 Two Mile Road, Bay City, MI 48706-2397) especially Karen Ropp.

Thanks so much, Karen Ropp!

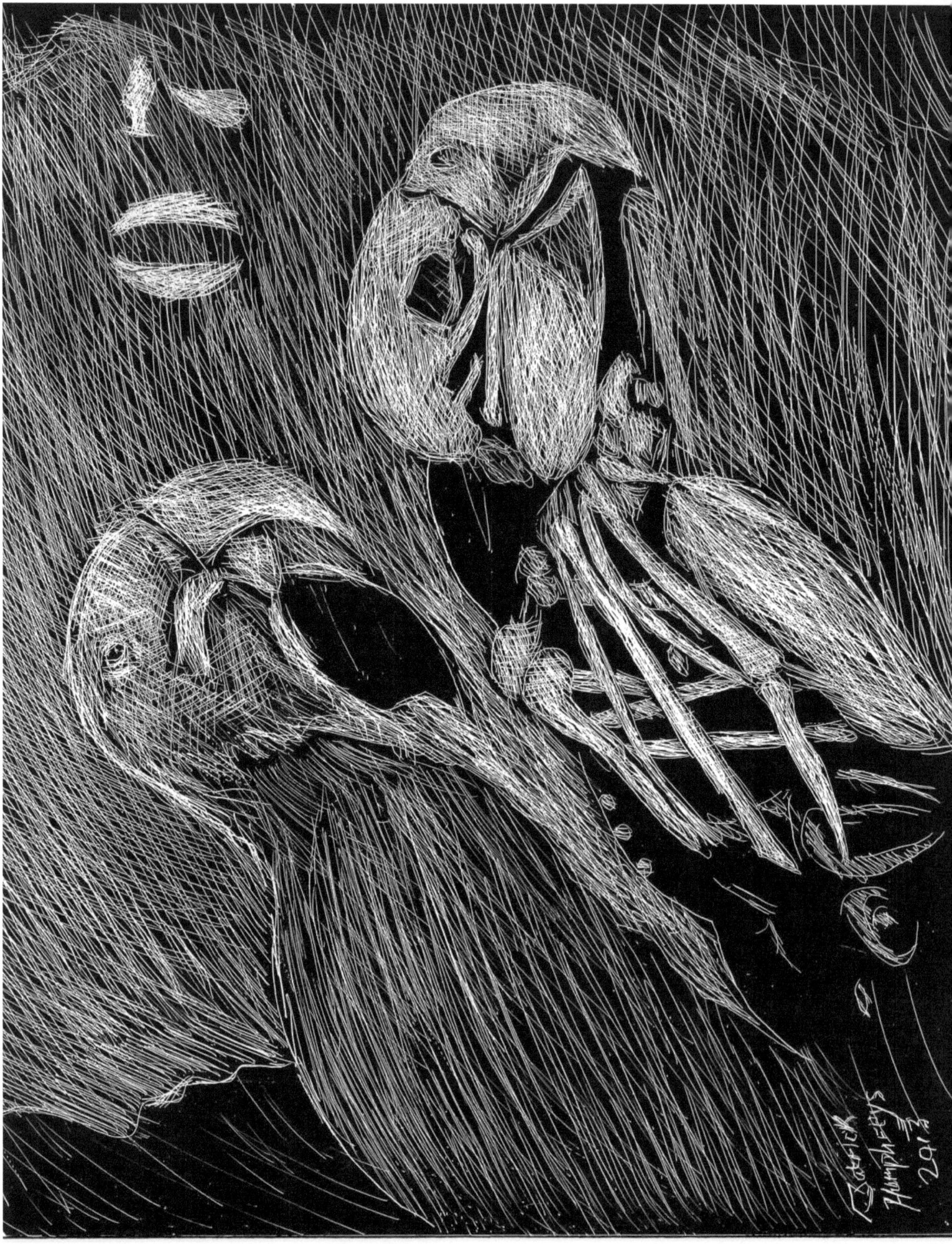

www.ingramcontent.com/pod-product-compliance
Lightning Source LLC
Chambersburg PA
CBHW050754180526
45159CB00003B/1459